Botero

Great Modern Masters

Botero

General Editor: José María Faerna

Translated from the Spanish by Alberto Curotto

CAMEO/ABRAMS

HARRY N. ABRAMS, INC., PUBLISHERS

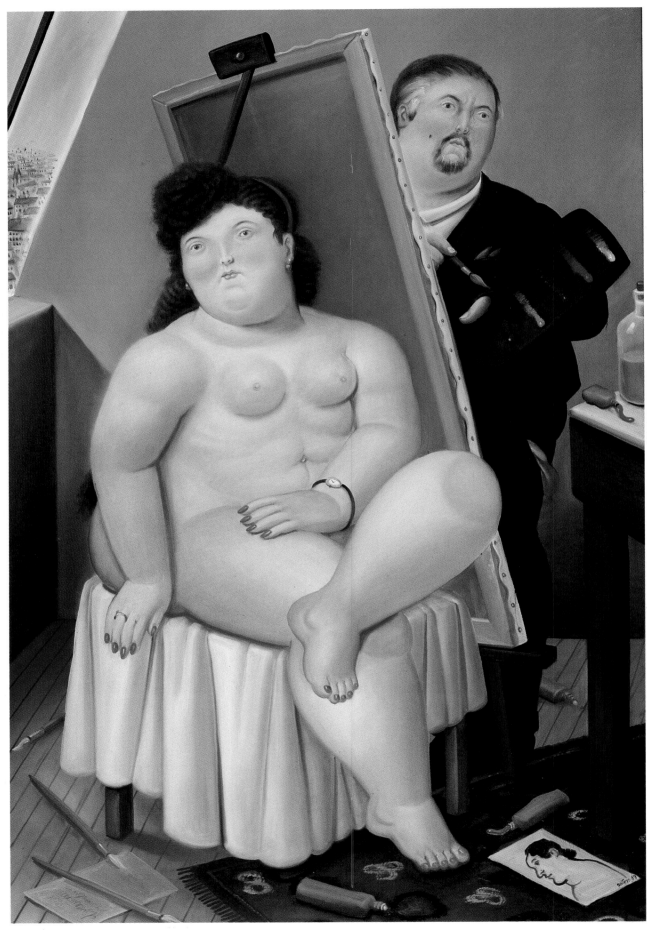

The Model, 1989. Oil on canvas, 79⅛ × 50¾″ (201 × 129 cm)

Fernando Botero: The Praise of Opulence

"**O**ne day I made a drawing of a mandolin and, by mistake, I traced a minuscule dot in lieu of the sound hole, . . . which made the instrument look swollen and massive," thus Fernando Botero described the genesis of his distinctive, inflated style. This was not the discovery of the Colombian artist's preference for massive forms, as he had had a similar realization a few years earlier while studying the paintings of Piero della Francesca. The mandolin episode, however, was a pivotal moment in Botero's artistic career. Extreme deformation has since become the hallmark of his figures. In fact, this trait is at times so powerful that it has been known to eclipse other aspects of his work.

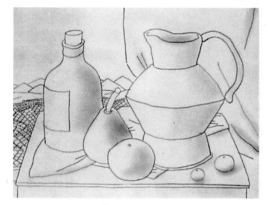

Still Life with a Bottle. *Generally conceived as preliminary studies for pastel or oil paintings, drawings attest to the importance of line in all of Botero's works.*

A Plastic World

Some critics, who see Botero as the standard-bearer of a new model of human beauty, have approached his paintings with such enthusiasm that it has proved harmful to an accurate understanding of his work. Artistic qualities of his painting aside, these apologists have praised the artist's dauntless confrontation of a society obsessed with thinness. The smug bodies in Botero's pictures could be seen as alternatives to the anorexic paradigm favored by much of contemporary culture. This oversimplification ignores the real intentions of the artist, who does not seek to comment on trends set by the modern world. Instead, Botero chooses certain motifs based strictly upon their formal possibilities. At the same time, he aspires to endow them with a sort of beauty that operates exclusively within the confines of the artistic realm. As the Peruvian writer Vargas Llosa once observed, the excessive anatomies are not degraded versions, rather, they are refinements of real beings in flesh and blood; they are "plastic beings, denizens of a fully autonomous world of forms and colors."

Botero's Classicism

As a connoisseur of art history, Botero traced the archetypes of his style in examples from the past. He discovered that in the history of ancient sculpture, the periods of artistic maturity—Egypt's Old Kingdom or fifth-century Greece, for instance—coincided with an exaltation of volumes and the portrayal of little emotion. So too in painting, Botero found similar traits in the monumental and hieratic figures of Giotto, Uccello, Ingres, and Piero della Francesca. Ever since observing a reproduction of *The Meeting of Solomon and the Queen of Sheba* by Piero della Francesca in the window of a bookstore in Madrid, he has been a constant reference in Botero's work.

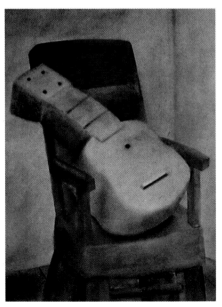

This watercolor painted in 1980 testifies to Botero's continuing interest in the motif of a guitar resting on a chair, a favorite subject since the 1950s.

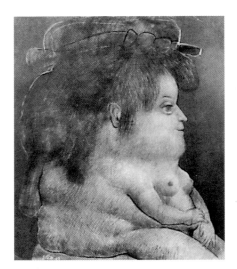

Figure in Profile, *1962. Along the lines of the* Mona Lisa, Age Twelve *(see plate 7) painted three years earlier, the fragmented strokes in this large-format charcoal drawing display the influence of Abstract Expressionism.*

When he was in Florence the Colombian artist embraced Bernard Berenson's ideas—collected in *Italian Painters of the Renaissance*—concerning what the art historian referred to as "the tactile values" of painting. Botero strove to elicit similar tactile sensations, which he observed in the artistic heritage of Pre-Columbian civilizations, as well as in the works of Mexican muralists such as Orozco, Rivera, and Siqueiros. In doing so, he freely altered the proportions of his figures, convinced that distortion is the essence of art, even in its most classic expressions. Alongside these archetypal underpinnings drawn from diverse reaches in the history of art, there are other, more indefinite forces that may help to further explain Botero's distinctive artistic development. Perhaps it was the influence of Colombia's natural exuberance—a land conducive to a certain degree of excessiveness—as described in the novels of Gabriel García Márquez. Maybe this consistent abundance was the artist's attempt to fulfill his childhood dream of being "bigger, sturdier, physically more important."

The Figurative Challenge

Even in an era often dominated by abstraction and the starkest forms of conceptualism, Botero remains solely in the domain of figurative art. With a few exceptions of works executed early in his career, Botero's pictures are highly polished, without the slightest trace of the artist's gestural brushstrokes. In constructing his images, however, he proceeds in a manner similar to that of an abstract painter, heeding only the demands of color and form. This translates into an expansion of volumes and the modification of the relative size and variety of the compositional elements. The common inclusion of snakes, flies, birds, and other seemingly incongruous figures has erroneously been regarded as evidence of the artist's allegorical intentions, or of certain fickle surrealist ambitions. The painter defends the purely formal aspects of his work, insisting that he only uses these figures to introduce various colors and shapes into his compositions. At the same time, Botero does not deny the presence of a satirical vein in some of his paintings, most typically in those works dealing with politics or the clergy. His is an invariably benign satire that, in the physical execution of the painting, naturally fades into the background.

Consistency

Few artists have been able to create a world as subjective and altogether distinctive as Botero's. Relying resolvedly on his independently formed beliefs, the painter proceeded to lay the foundations of his own plastic idiom, which have remained consistent for several decades. Even throughout the most difficult periods in his life—when an *ARTnews* critic described his figures as "fetuses begotten by Mussolini on an idiot peasant woman" or after the death of his young son, for example—Botero's work has retained its characteristic sage ingenuousness, as well as its inherent contentment and opulence.

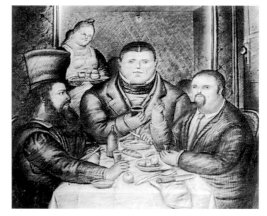

The Dinner Party with Ingres and Piero della Francesca, *1972. In this charcoal drawing Botero portrays himself in the company of two painters who had the most significant influence on his work.*

Fernando Botero/b.1932

Although Botero has lived in a wide array of places, his Colombian homeland plays a consistent and crucial role in his work. He was born in 1932 in Medellín, a city located in the heart of the Antioquia province. The artist spent his early years in this region characterized by its precipitous terrain, which is intersected by the spurs and foothills of the Andes, and furrowed by hard-to-reach valleys. The young man's restless nature and artistic inclinations clashed with his provincial surroundings. A revealing episode from those years is Botero's expulsion from high school following the publication in the local newspaper of his article entitled "Picasso and Non-Conformity in Art." His discussion of the importance of distortion in Picasso's works was deemed obscene by the local authorities, who had already reprimanded Botero for previously publishing some of his own drawings of nudes.

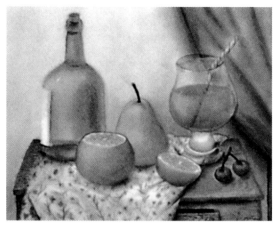

Still Life with a Bottle, *1983. This small-format watercolor captures the same monumental aura and distinctive spirit of abundance typical in Botero's larger works.*

First Steps

Expulsion from school and the attendant suspension of his scholarship forced Botero to continue his studies in the nearby town of Marinilla, where he supported himself by illustrating a number of periodicals and designing theater sets. In the early 1950s, after completing his studies Botero moved to Bogotá, where he consorted with the cream of the Colombian *intelligencija*. Within a few months of his arrival in the capital city, and soon after his nineteenth birthday, Botero had his first solo show. With the sale of several works he was able to afford a short stay in the Caribbean town of Tolú. The few months he spent there were devoted almost entirely to painting. The following year Botero held a second solo show, in which he exhibited works executed in Tolú and in the months immediately thereafter. This group of paintings, heavily influenced by Gauguin, as well as the early works of Picasso, sold extremely well. This income along with money from a painting award enabled Botero to fulfill his dream of traveling to Europe.

The European Dream

Botero arrived in Barcelona in the summer of 1952. The painter, whose knowledge of modern art was limited to reproductions he had seen printed in books, was quite disappointed by the scarcity of actual works available to him in the Catalan city. He soon moved to Madrid, where he would reside for several months. In the Spanish capital Botero enrolled in the Academia San Fernando. When he was not attending classes he often visited the Museo del Prado, attracted by its collection of works by Velázquez and Goya. From Madrid he moved to Paris, where, feeling an increasing sense of kinship with the old masters and evermore estranged from avant-garde styles, Botero went to few museums other than the Louvre. At the end of the summer of 1953, after his brief sojourn in the French capital, he settled in Florence and enrolled in the Fine Arts Academy of San Marco to learn fresco painting techniques. His stay lasted more than two years and it proved to be the most important period of his artistic training. This formative stage was crucial in several respects. Not only was Botero able to observe firsthand the creations of Giotto and the Renaissance masters, he

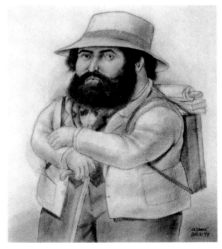

Cézanne, *1994. As he had done previously with Ingres and Piero della Francesca, here Botero pays homage to Cézanne, re-creating the master of Aix-en-Provence as a somewhat uncouth peasant.*

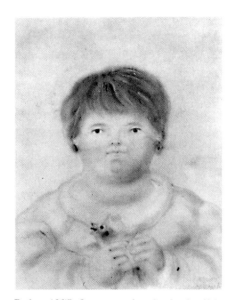

Pedro, *1975. One year after the death of his son Pedro, Botero continued to mourn his loss in works representing the child with a blend of tenderness and longing.*

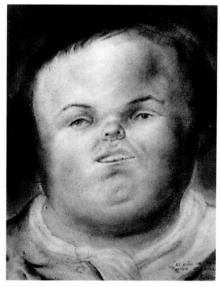

The Child from Vallecas (after Velázquez), *1973. Attempting to delve deeper into the essence of his favorite painters' works, Botero reinterpreted their most famous pictures from his personal and peculiar point of view.*

also profited greatly from his teacher, Roberto Longhi, as well as from the writings of Bernard Berenson.

The Two Americas

After his enriching experiences in Italy, Botero's return to Colombia resulted in a bitter homecoming. The exhibition in Bogotá of the works he had painted in Europe was a complete failure; he did not sell a single picture. At the outset of 1956, in the aftermath of this harsh disappointment, the artist left Colombia and established residence in Mexico City with his new wife, Gloria Zea. It was there that the celebrated mandolin episode took place, and under the influence of Orozco, Rivera, and Siqueiros—the great muralists he had admired throughout his earliest Colombian phase—Botero began to develop his distinctive style of overblown forms. That same year, his work was shown for the first time in the United States, and his success began to grow. At age twenty-six, Botero was appointed professor of painting at the Art Academy of Bogotá, and his pictures continued to attract an increasing number of buyers. This was, however, a difficult period for Botero in both his personal life and his career. In 1960 he began renting a small apartment in New York City while finalizing his divorce from Gloria Zea. At the same time, he endured the unequivocal hostility of art critics and his New York colleagues who, for the most part, belonged to the Abstract Expressionist school. The turning point in Botero's career came in 1961 when Dorothy Miller, then curator of museum collections at The Museum of Modern Art in New York bought his *Mona Lisa, Age Twelve* (see plate 7).

Recognition

This purchase brought the definitive consolidation of the artist's fame. In the mid-1960s, the ocher tones and heavy brushwork of his previous paintings made way for a new style, with polished surfaces and more vivid colors, characteristic of his mature works. For the next several years Botero resided alternately in Colombia, Europe, and New York. In 1970 his son Pedro was born to his second wife, Cecilia Zambrano. In a tragic car accident just four years later, the child died and the painter suffered severe injuries.

In the ensuing years, sculpture came to occupy an increasingly important place in Botero's career. He took up residence in 1983 in Pietrasanta, a Tuscan town famous for its foundries and numerous marble quarries. On account of this growing emphasis on sculpture, he began spending several months each year in Italy. For Botero, this was a time of renewed and intense activity in both sculpture and painting, the latter frequently depicting bullfighting themes. These works were well received and soon translated into an uninterrupted series of exhibitions. The wide-ranging retrospective of his work, held at the Hirshhorn Museum and Sculpture Garden in Washington, D.C., in 1979, was the first in a series of similar shows. Subsequent exhibitions were held in Chicago, New York, and Madrid. Neither the fame nor the high prices fetched by his works has changed Botero's nomadic habits. To this day, the artist continues to divide his time between Colombia, New York, Paris, and Pietrasanta.

Plates

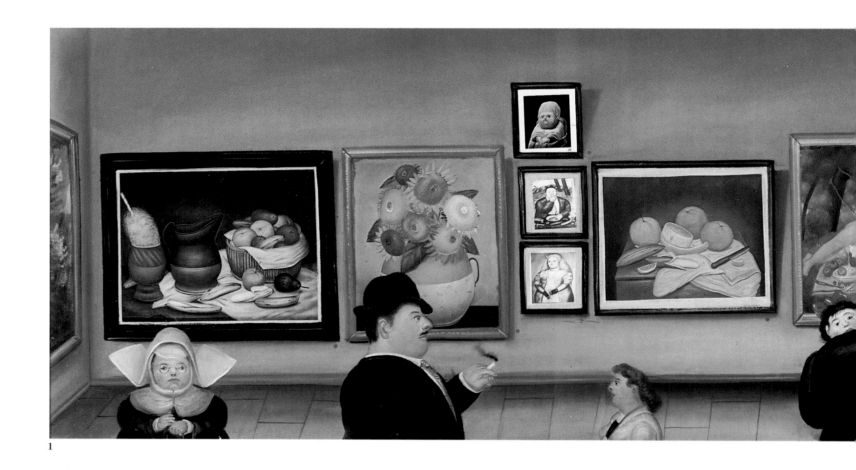

1

Self-Portraits

For the most part, Botero's forays into portraiture have taken the form of self-portraits, in which he subjects his own figure to the same deforming logic that he applies to all others. He does so with a good amount of humor, especially when echoing such illustrious antecedents as Rembrandt or de Chirico. He portrays himself disguised as some of the most diverse characters—projections, perhaps, of his unfulfilled desires—ranging from Spanish conquistador to gallant bullfighter. In some instances, the Colombian artist portrays himself as a tiny figure, somewhere between the medieval representation of the donor, and the self-portraits of Velázquez depicted alongside his eminent models. In other instances, however, Botero's presence is rendered almost imperceptible, as his distinctive visage timidly emerges from some minuscule cameo.

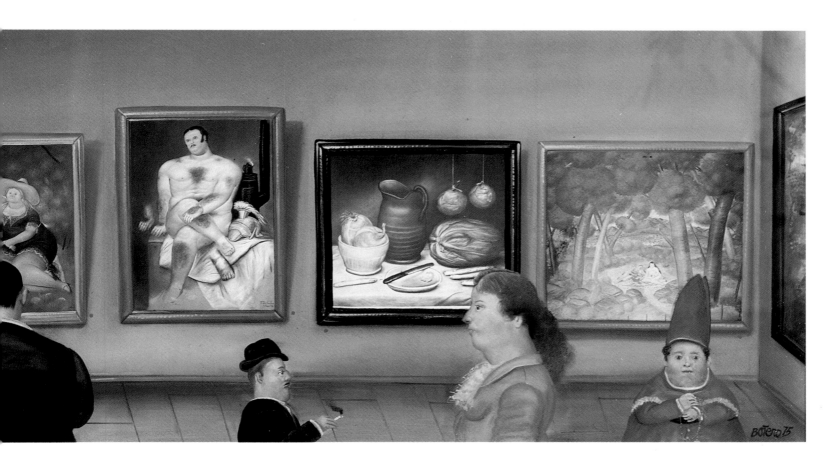

1 The Botero Exhibition, *1975. The buxom lady, the nun, the mustachioed man with
an absentminded air, and the bishop in his spectacular scarlet attire, all characters typical
of Botero's universe, visit an art show of pictures by their creator. This interpretation of the
traditional painting-within-a-painting theme has two representational levels. The visitors'
figures are actually painted, while the pictures at the exhibition are reproductions pasted
onto the canvas. Here, Botero demonstrates that the distorting principle behind his work is
not perfunctory. As he once stated in an interview, he is not affected by any type of
psychological or ophthalmic disorder, such as those that some "shortsighted" art historians
have ascribed to El Greco.*

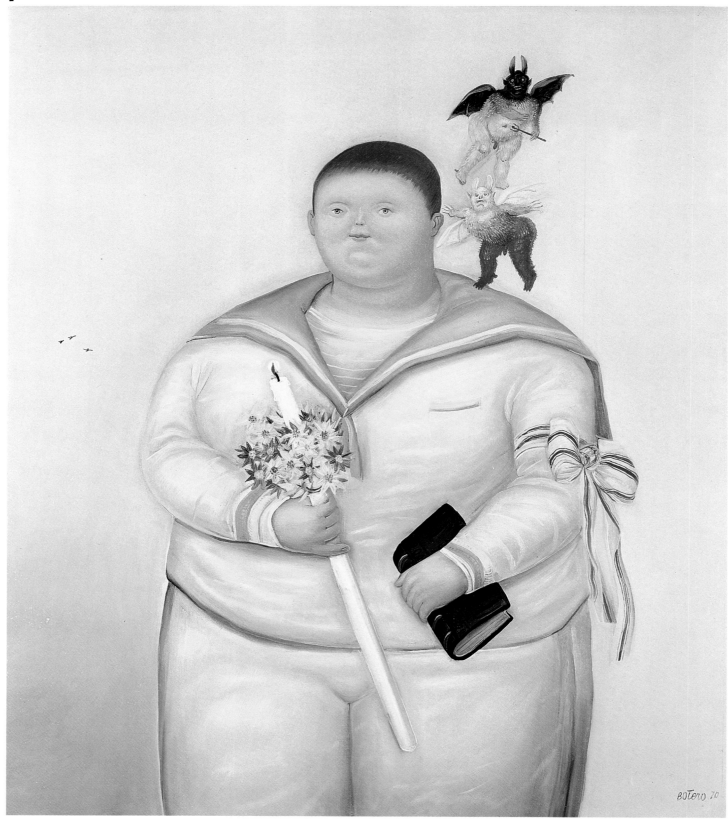

2 Self-Portrait the Day of My First Communion, *1970. Similar to the demons that Saint Francis drove out of Arezzo in Giotto's fresco, which Botero admired firsthand in Assisi, two minuscule winged figures flee from the child on account of the imminence of his first communion. The boy is altogether unlike the artist, who in reality was a diminutive child.*

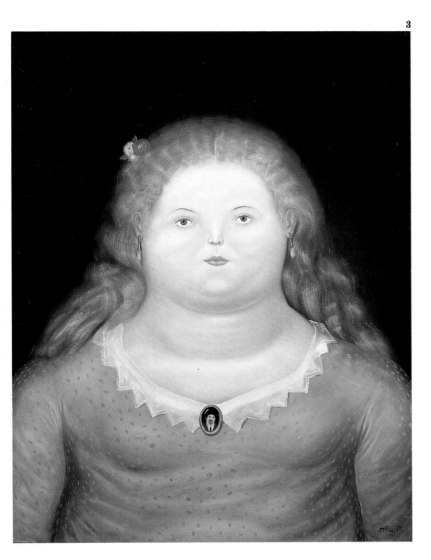

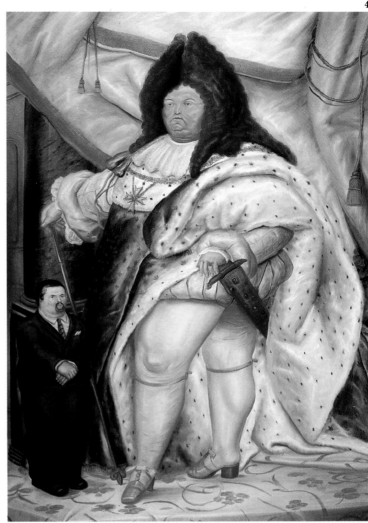

3 Delfina, *1972. Here again, Botero employs the time-honored painting-within-a-painting device. In this instance, he uses it as a pretext to introduce a tiny self-portrait within the monumental figure of Delfina. Albeit seemingly engrossed in her thoughts, she gazes at the viewer, a pose highly atypical in Botero's paintings. More often characters are unadulterated physical presences, staring blankly beyond the picture plane, and making no attempt to establish emotional connections with their viewers.*

4 Self-Portrait with Louis XIV (after Rigaud), *1973. With this nearly ten-foot-high canvas, Botero provides his own peculiar interpretation of a seventeenth-century courtly portrait. Few models are as congruous with the Boteroan canon as the supercilious Sun King. The sovereign's magnificent demeanor and sumptuous robe dramatically contrast with the diminutive figure of the painter, who, in his sober attire and circumspect air, acts as a sort of emphatic signature.*

5

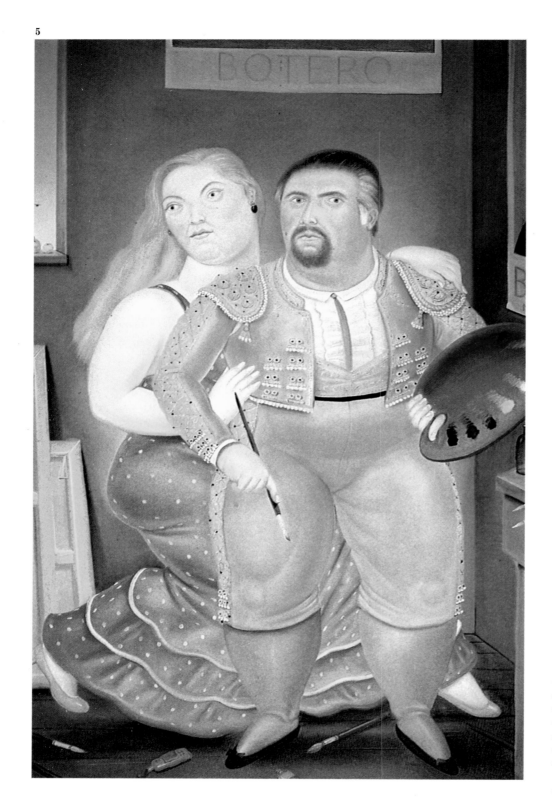

5 Self-Portrait with Sofía, *1986. Botero begin painting bullfighters after attending a bullfighting school as a child and discovering he lacked the skills to become a successful matador. Since that time the artist has painted a conspicuous number of works inspired by the world of corridas—so many, in fact, that he hoped "whenever thinking of bulls one would also think of Botero."*

6 Self-Portrait, *1994. By depicting himself in this everyday setting, Botero demonstrates that the value of a painting does not reside in the richness of its motifs, but in the artist's ability to exploit the formal possibilities of the motifs to their full extent. Dominating the composition, the painter's apron, which is supple in appearance and strewn with tufts of recently cut hair, evokes the splendors of the ermine mantles in Botero's royal portraits.*

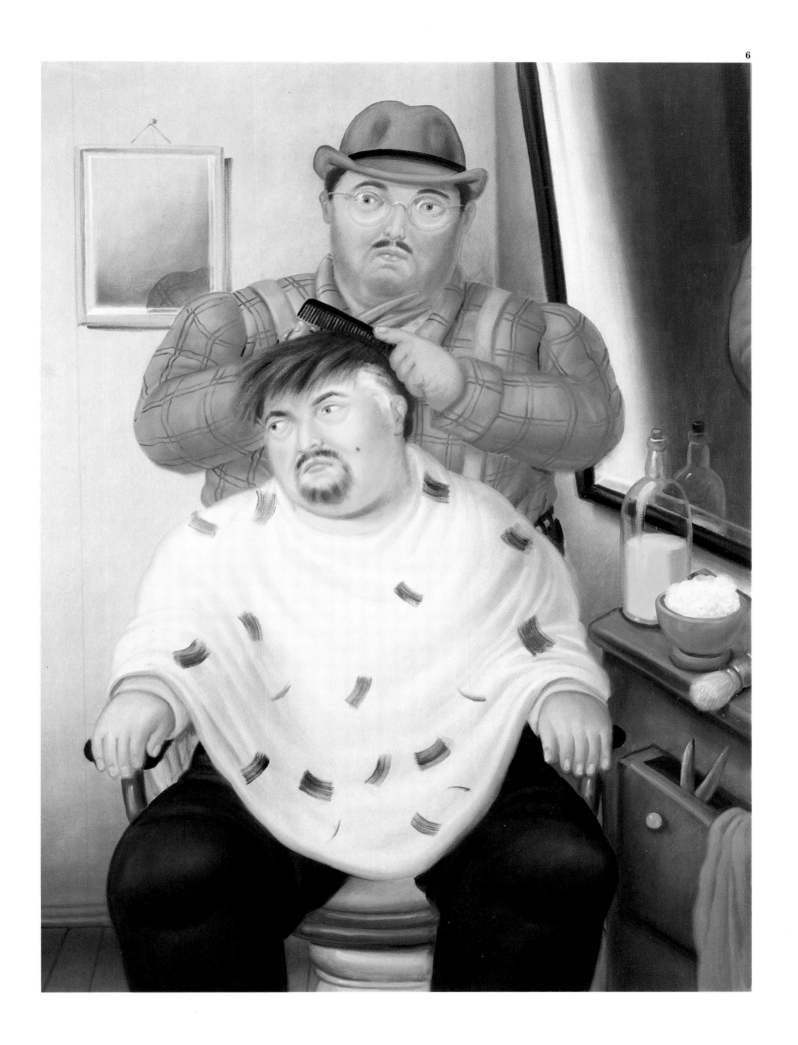

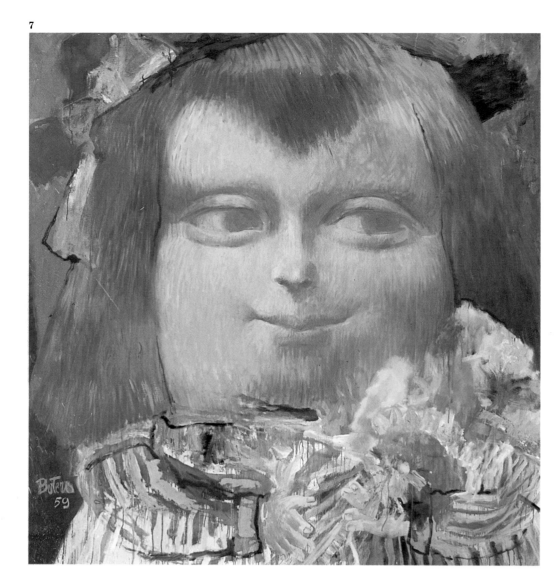

7 Mona Lisa, Age Twelve, *1959.*
This work signaled a crucial
change in Botero's career. Its
purchase in 1961 by The
Museum of Modern Art in New
York brought him recognition in
a number of artistic circles,
which had previously rejected
him with considerable
harshness. Despite the obvious
distance separating Botero from
the Abstract Expressionist
school, the Colombian painter
adopted a type of brushwork
reminiscent of works by such
artists as Willem de Kooning and
Franz Kline.

Paraphrases

One of the most distinctive chapters in Botero's career is the one comprising his renderings of celebrated paintings from the history of art. Like Picasso and Bacon, the Colombian painter borrows motifs from a shared cultural heritage. Botero's intention, however, is not to copy Leonardo, Caravaggio, or Mantegna, since his pictures are free interpretations retaining only the subject matter of the originals. By stripping the motifs of all their stylistic traits he converts them into genuine Boteros. Although a certain touch of irony infiltrates these works, the artist's goal is not to create caricatures. Rather, they are his attempts to distill the true essences of paintings while conforming to the formal aspects of his particular style. The artist has practiced reworking art from the past since executing copies of paintings by Velázquez at the Prado, or when attending fresco classes in Florence.

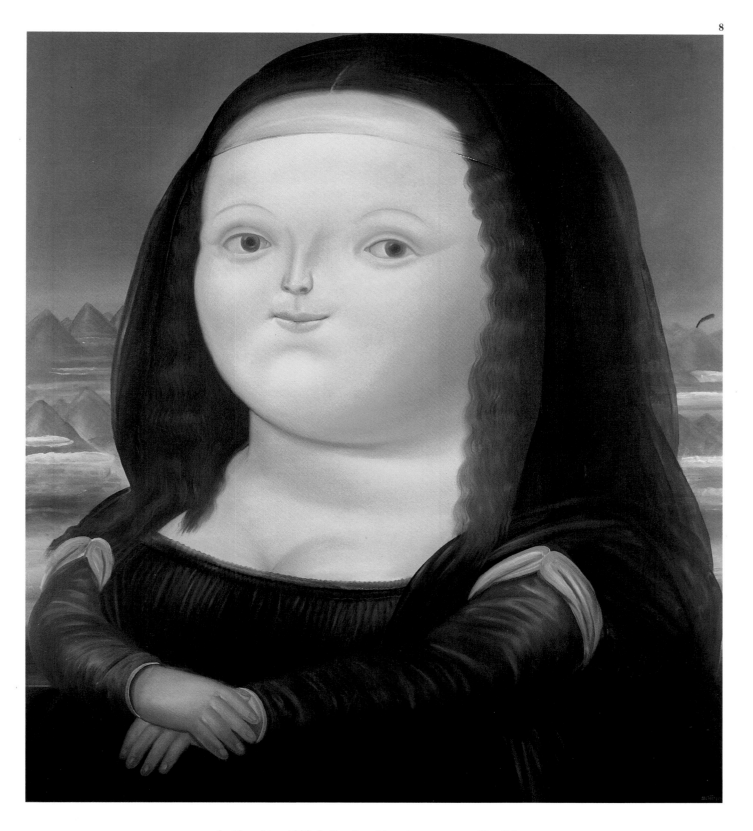

8 Mona Lisa, *1978. In the almost twenty years separating this painting from the preceding one, Botero abandoned his experimental mode to establish the style characteristic of his mature works. There remain no obvious traces of the painter's early expressionistic ambitions. The soft palette and minute brushwork, more in keeping with Leonardo's example, produce a velvety texture that underscores the sensuous character of the model's volumetric distortion.*

9 Menina (after Velázquez), *1978. Since his first opportunity to copy Velázquez's paintings at the Prado, Botero has exhibited a profound admiration for the Spanish artist, and has repeatedly borrowed Velázquezean motifs for his own work. One of his favorite characters is the princess Margarita, whose enormous crinoline echos Botero's spherical rendition of her torso and face.*

10 Rubens and His Wife, *1965. This brushwork is similar to the painter's technique from the late 1950s. The figures are less indebted to the exuberant carnality of Rubens than they are to the unruffled and monumental figures of Piero della Francesca.*

Nudes

Botero has repeatedly denied any specific fascination with corpulence. The abundance of his figures—particularly evident in his nudes—cannot merely be identified as obesity. Labeling them "fat" is not an accurate description of his characters, insofar as they do not belong to the world of mortals, but to that of the pictorial imagination. Nowhere else in Botero's work is his quest for the expression of the tactile values of painting so manifest, nor is his intention of eliciting enjoyment through an exaltation of life easier to identify. In the artist's own words, he strives to "create sensuousness through form." This sensuousness, however, is almost always stripped of all sexual connotations, as his characters possess diminutive genitals and retain chaste attitudes throughout. Their welcoming bodies are not meant to engender urges of carnal desire. More frequently, the only yearning they elicit is to caress, at least with one's gaze, the sinuous geography of their skin, and explore their mysterious texture.

11

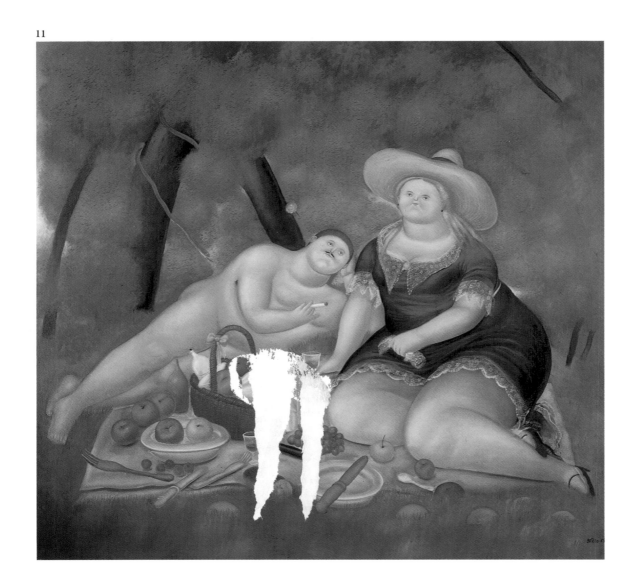

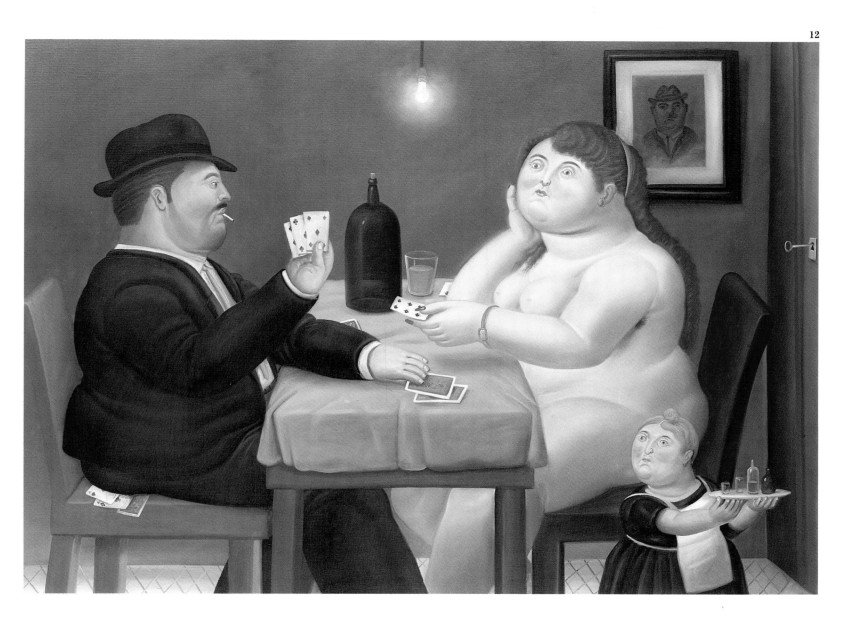

11 Le Déjeuner sur l'Herbe, *1969. Botero inverts the terms of Manet's painting of the same title, which earned the l⟨⟩ accusations of obscenity. Here the woman is entirely dr⟨⟩ while her companion is presented in nearly com⟨⟩ association of the two characters, even taking i⟨⟩ serpentine figure slithering down the tree trunk, ⟨⟩ ar completely devoid of any erotic connotation. Bot⟨⟩ equ⟨⟩ employs snakes with the merely formal intention ⟨⟩ntro⟨⟩g a touch of color in a specific location on the canvas.*

12 The Card Player, *1988. As Cézanne had done ⟨⟩ is pa⟨⟩ng of similar subject matter, Botero places a table at t⟨⟩ ⟨⟩enter ⟨⟩is composition and provides a lateral view of the two ⟨⟩rd playe⟨⟩s. This is the extent of the commonality of the two works. In Botero's version the second player is a splendid female nude, while in the foreground, without regard to the conventions of proportion, a minuscule waitress directs the viewer's gaze to the cards the man is slyly concealing on his chair.*

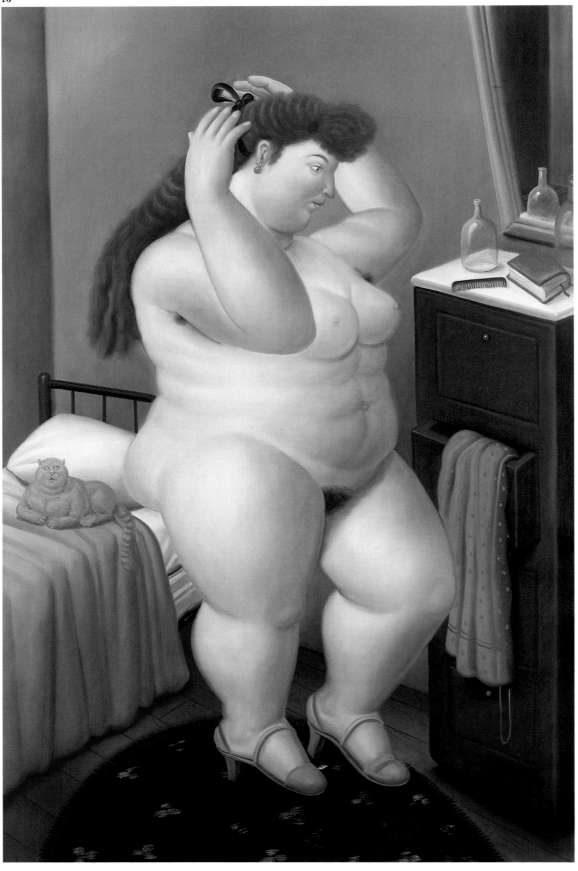

13, 14 Venus, *1989;*
The Bath, *1989.*
*Throughout the history
of art, especially in
Impressionist paintings,
the theme of the* toilette
*has served as an excuse to
represent the female nude.
The peaceful atmosphere
shared by all of Botero's
works intensifies in these
intimate scenes, where the
inherent tranquillity of
his characters finds its
most suitable locale.*

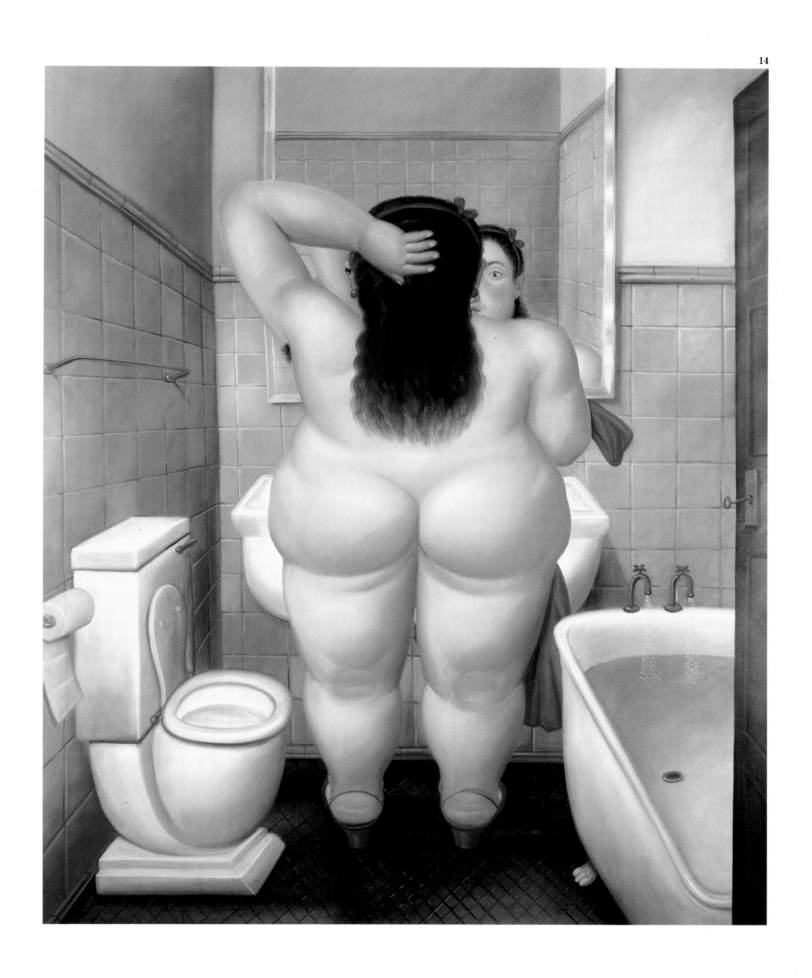

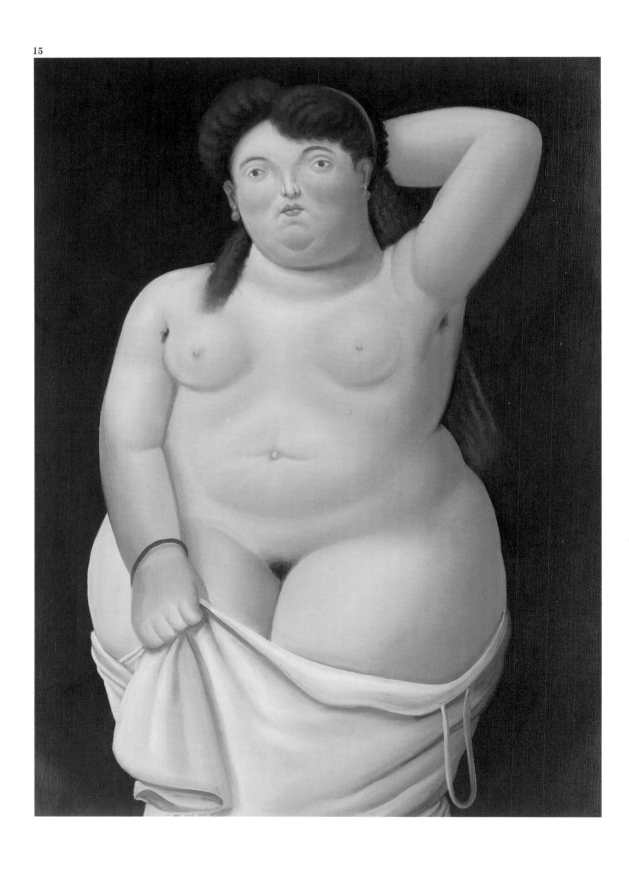

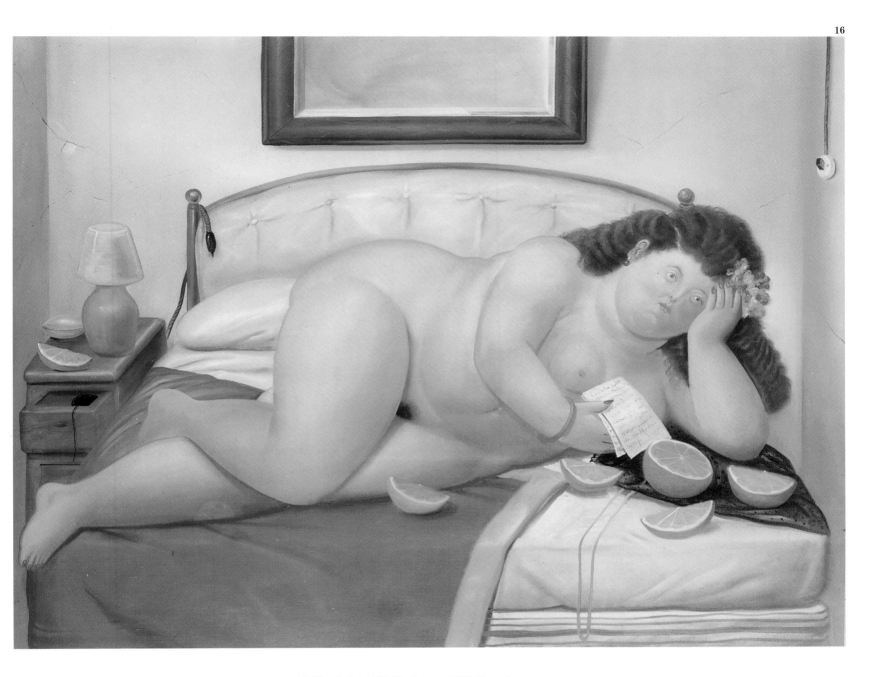

15, 16 Nude, *1988; The Letter, 1976. Botero's nudes
are indeed sensual beings, however, as Vargas Llosa
observed, the "elephantine women with their immense
thighs and bovine necks are fleshy but not carnal.
Their sex is so tiny as to become almost invisible, a
tuft of down lost and embarrassed amidst the gushing
masses of their legs. . . . They are placid, innocent, and
maternal fat creatures."*

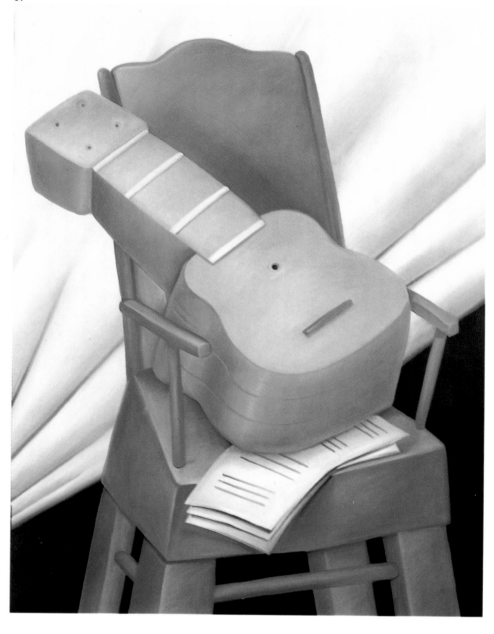

Still Lifes

It was with a still life that Botero launched his own peculiar style of inflated volumes, and it is precisely in this genre that the underlying principle of distortion is most readily observed. It is often a slight detail—such as the tiny bite mark on a pear, the slim handle of a pitcher, or the minuscule sound hole at an instrument's center—that acts as a catalyst in the process of proportional modification, and the ensuing alteration of the composition's very meaning. In these works, where human figures seldom appear, Botero subordinates the anecdotal aspects to the formal ones. As in his portrayals of people, which at times may indeed be slightly satirical in nature, deformation is never meant to be negative or critical. In Botero's own words, "I don't treat oranges or bananas any differently [than any other compositional elements], and I obviously have nothing against these fruits."

17 Guitar and Chair, *1983. As in the archetypal mandolin painted thirty years earlier, Botero again reduces the diameter of the sound hole to inflate the rest of the instrument. The bloated appearance is enhanced by the thickness of the guitar's neck, the disproportionate depth of the sound box, and the massiveness of the musical score.*

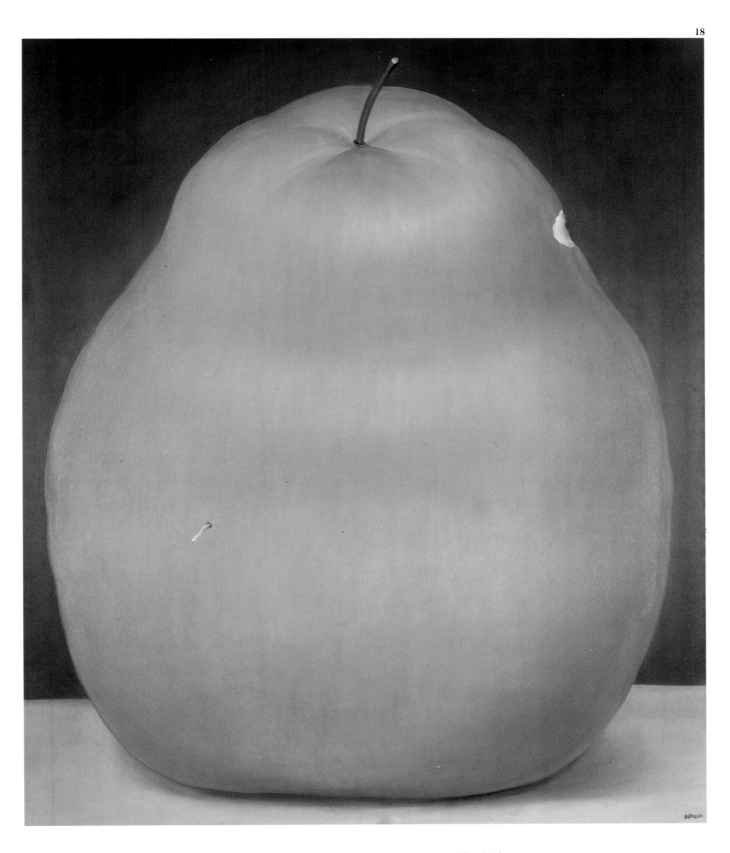

18 Pear, *1976. Despite the ostensible similarity to Magritte's disquieting images of hypertrophied fruits, Botero's intentions are quite alien to the Surrealist spirit. With a canvas more than six feet high, and his habitual alteration of the size of secondary elements, such as this stem, bite mark, and worm, Botero allows a pear to take on monumental proportions.*

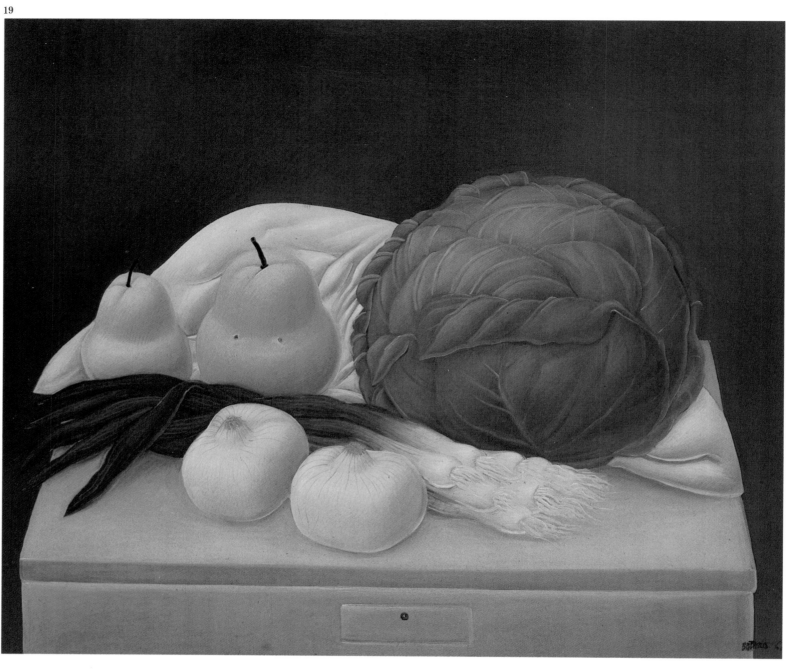

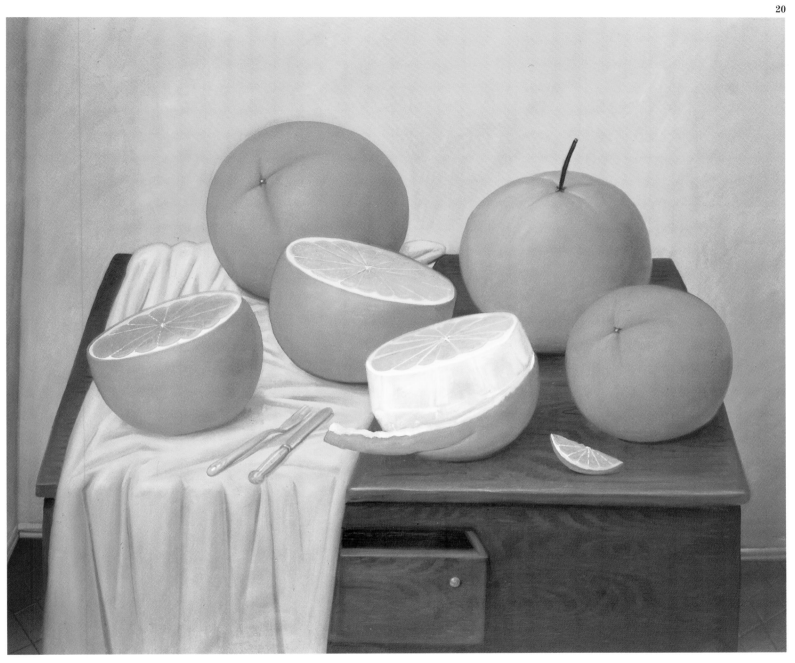

19, 20 Still Life with Cabbage, *1967;* Oranges, *1989. The neutral quality of the subject matter in still lifes enables the painter to focus on purely formal matters. As Botero once stated, "I do not wish to convey metaphysical feelings. . . I want to view themes from a painterly perspective, not as a commentator, a philosopher, or as a psychoanalyst. I do not want to express profound thoughts on the world or on life in general. I wish I could always paint as if I were depicting fruits."*

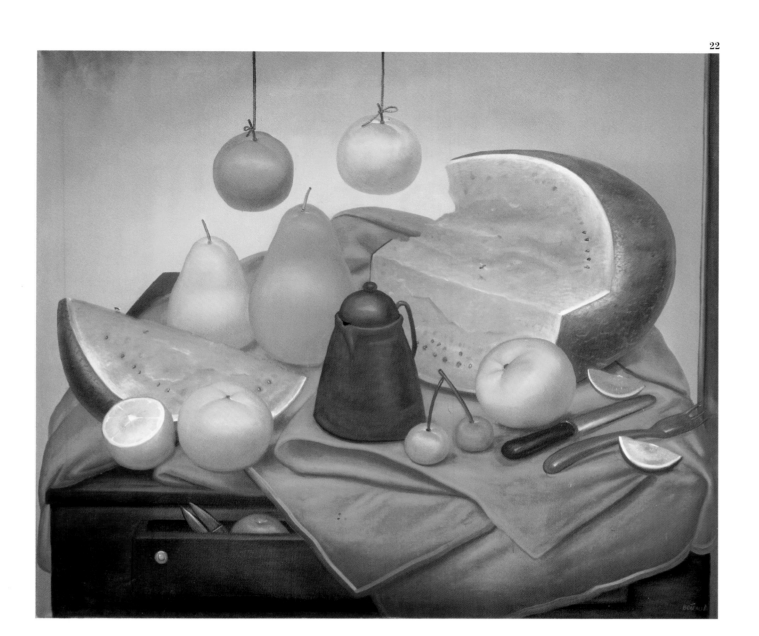

21, 22 Happy Birthday, *1971*; Still Life with Watermelon, *1976.*
*Botero rarely depicts apples in his still lifes because, according
to him, they are a fruit "for snobs." Instead, he looks to his
Colombian roots and prefers to paint "the original fruits from
the Tropics," such as oranges and bananas.*

23

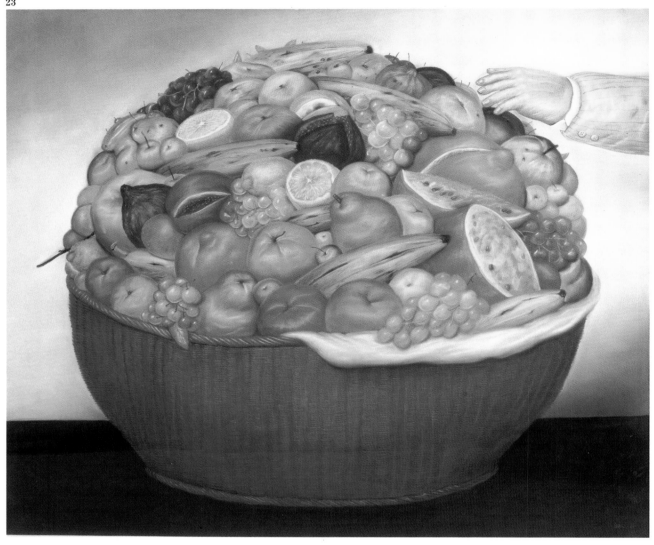

23, 24 Fruit Basket, *1972; Flowerpot, 1974. Each piece of fruit and each flower retains its specific traits through careful and individual rendering. Small details, such as a falling petal or a pair of fluttering flies, allow the artist to introduce touches of color on an otherwise homogenous surface, heightening the aspect of depth.*

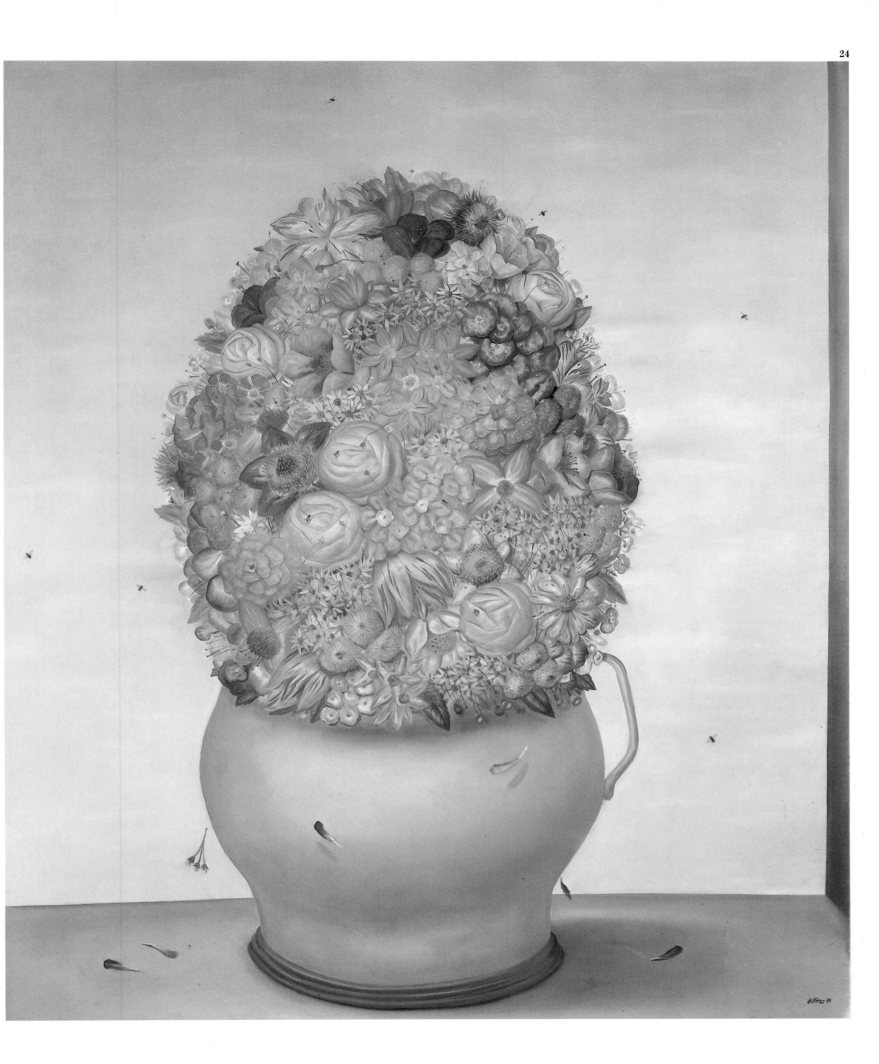

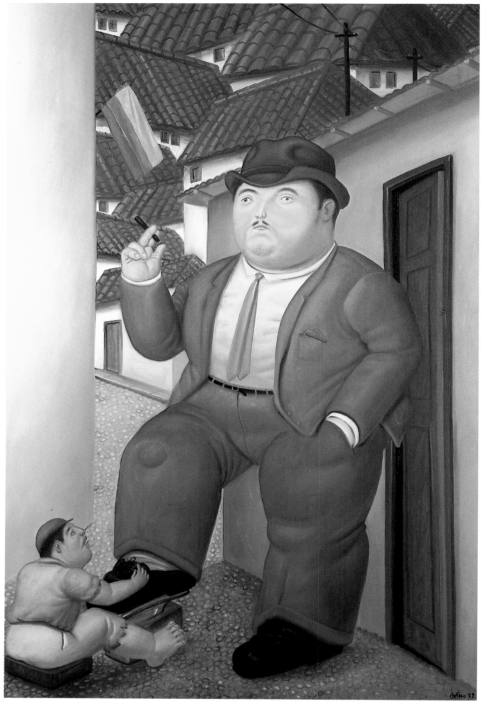

25 The Bootblack, *1989. While the unequal size of the two figures and the apparently servile attitude of the title character may seem to be a comment on the vast separation between Colombia's haves and have-nots, one must recall the painter's disinterest in social criticism.*

26 A Stroll by the Lakeside, *1989. Botero has provided several explanations for the abundance of clerics in his paintings. Initially, there was a prevailing critical intent: the denunciation of the overwhelming, and not always beneficial role of the Church throughout Latin America. Subsequently, this thematic choice was determined exclusively on formal grounds, as the artist's preference for bishops was inspired by the magnificent chromatic interplay of their robes. He provides yet another motive. "There is a very simple reason behind my choice to depict priests. While I am not a religious person myself, religion does belong to my artistic heritage. Besides, priests are equally typical of the Quattrocento, which I love so dearly, as of everyday life in contemporary Latin America."*

Colombia

Latin America, and Colombia in particular, is a constant presence in Botero's work. Physical estrangement from his native land has not changed Botero's belief that he is "the most Colombian of all Colombian artists." He introduces a number of elements that, although stemming from folk art, lose most of their naïf character in his hands. Early in his career, Botero's paintings displayed a certain political intent that gradually vanished as he grew increasingly skeptical or, as he confessed, increasingly indifferent. Geographical distance enabled the artist to idealize his homeland with great imaginative freedom. "Somehow, I paint Colombia the way I wish it were, although it is not like this. Mine is an imaginary Colombia that is at once like and unlike the real Colombia."

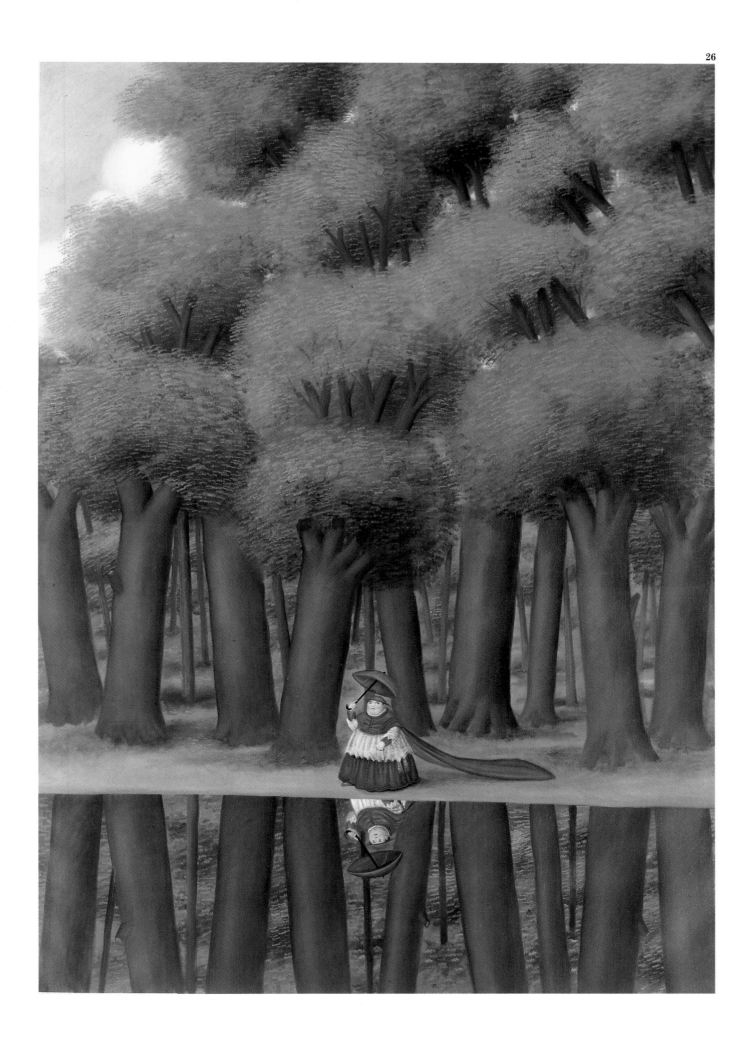

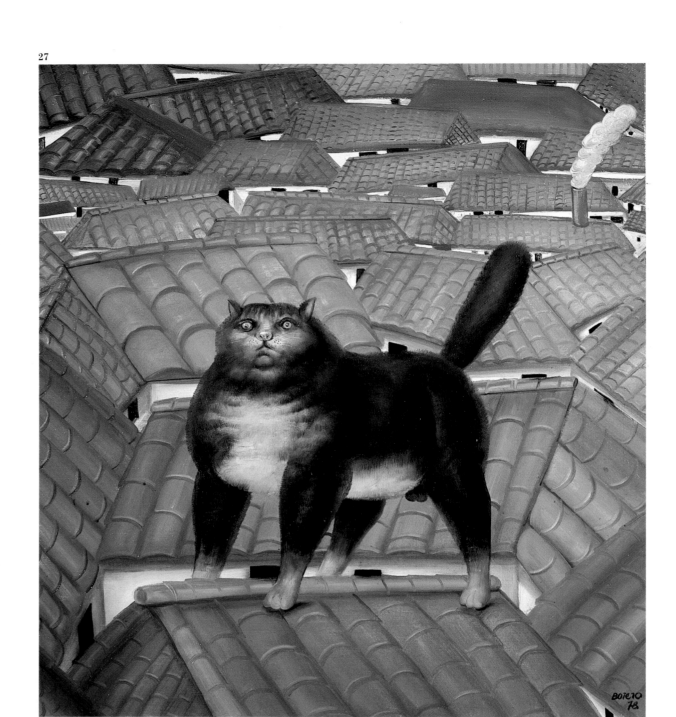

27 Cat on a Roof, *1978. The labyrinthine pattern of reddish roofs, which recurs frequently in Botero's work, is reminiscent of the intricate relief of many Colombian towns. The zigzagging interplay of planes, amid which disproportionately large burglars or colossal cats sometimes lurk, calls back to the peculiar use of perspective in the paintings of such artists as Ambrogio Lorenzetti and Giotto.*

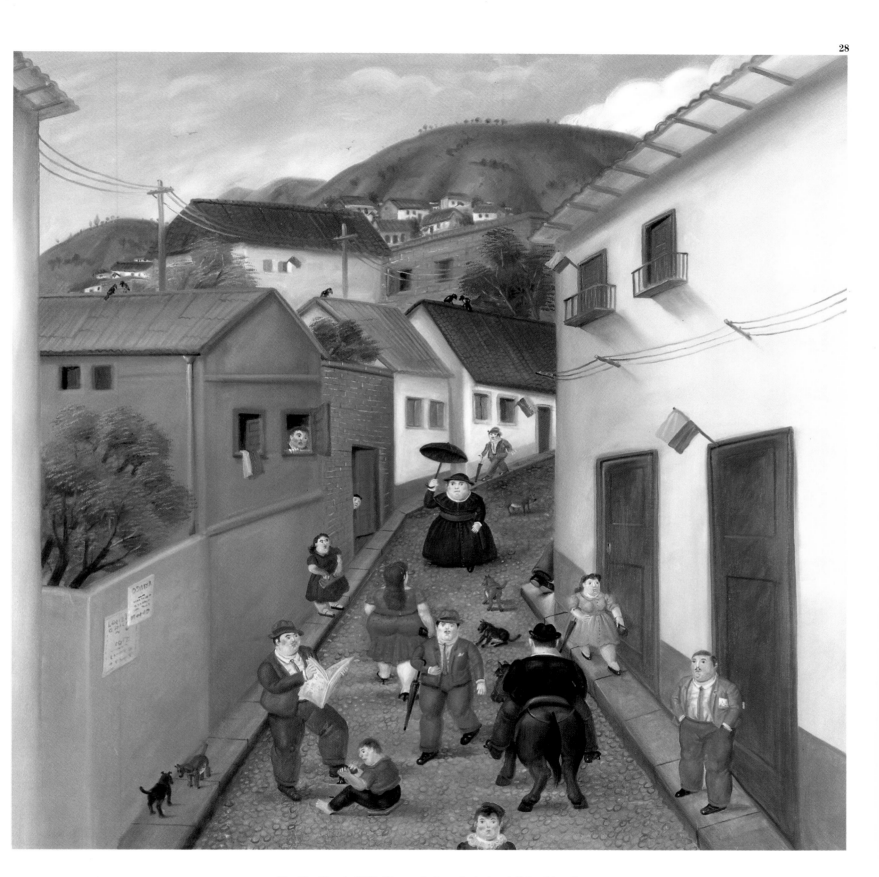

28 The Street, *1987. The profusion of tricolored Colombian flags indicates that the scene is most likely occurring on a national holiday. This festive occasion has attracted a number of people bearing Botero's unmistakable stamp, from the fop in his Sunday best, and the horseman, to the shoeshiner, and the spherical priest, whose girth occupies nearly half the width of the street.*

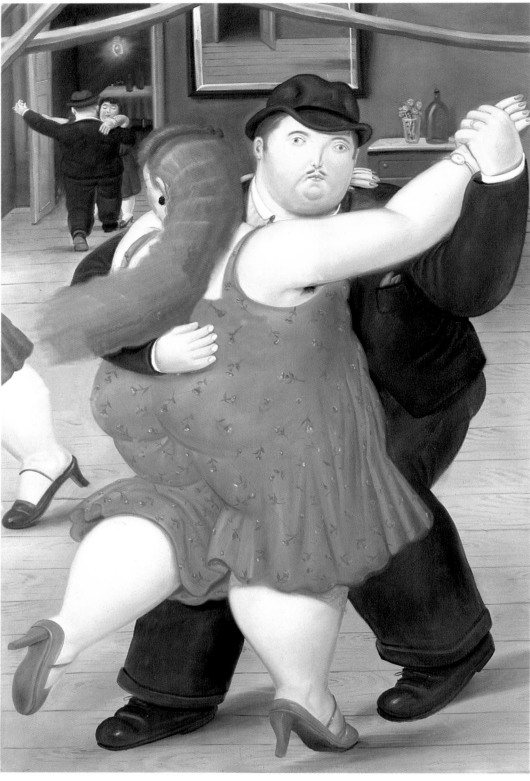

29, 30 Dancing, *1987; The Musicians, 1979. In those rare cases when Botero's characters are portrayed at work, their occupations, such as prostitute or musician, typically involve somebody else's leisure. Their static condition, even when dancing, is seemingly aimed at protracting their placid situation. They dwell in that utopian "existential Sunday," according to Gilbert Lascault's felicitous definition, immune to all misfortune and evil.*

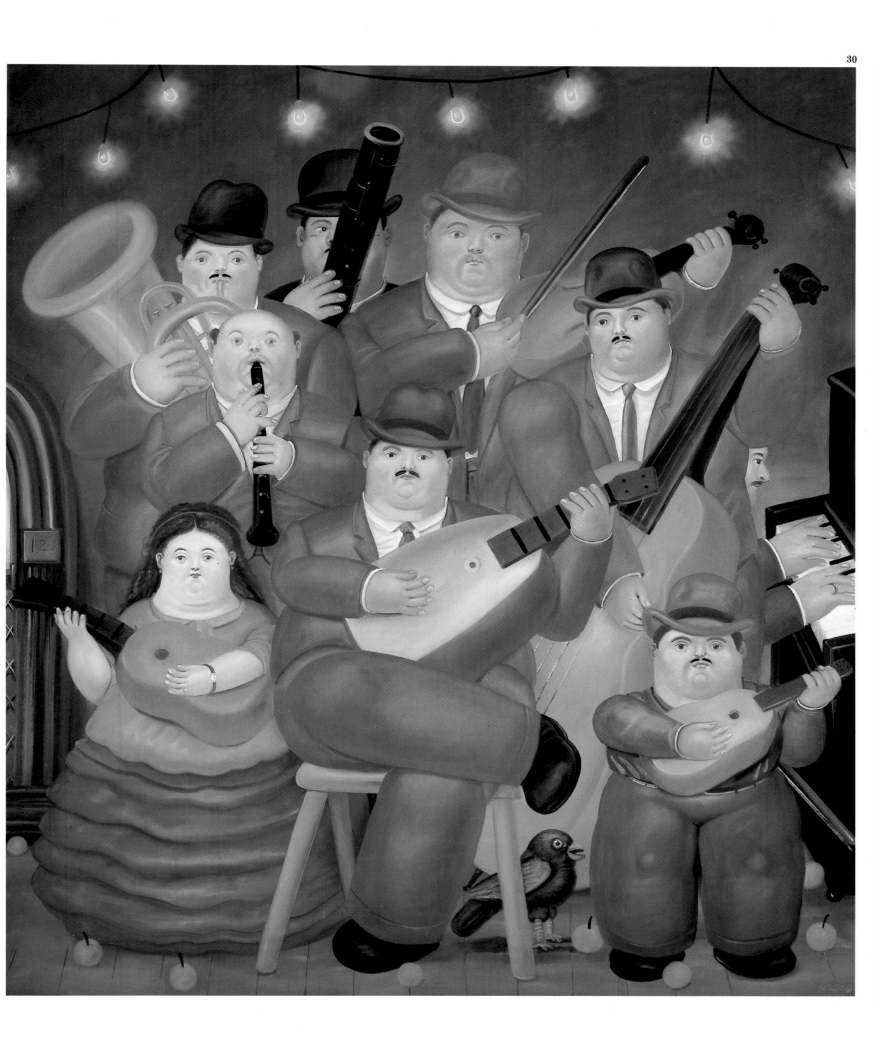

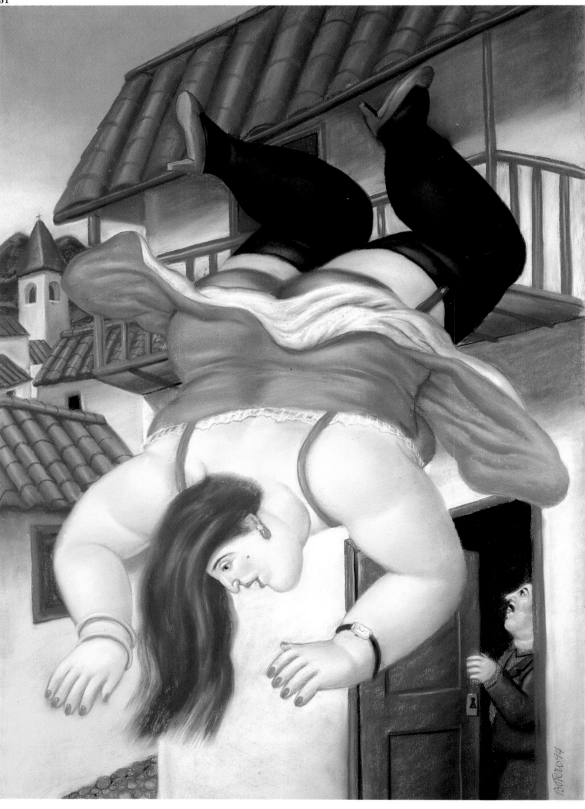

31, 32 Woman Falling from a Balcony, *1994;* Melancholia, *1989.*
In Botero's hands, a tragic motif like that of a woman plummeting
headlong to the ground, or a slightly outlandish one, such as a
robust cross-dresser secretly contemplating his own image,
acquires comedic tones. The viewer is encouraged to divorce the
image of the falling woman from her imminent destiny and freely
admire her generous shape. In the same vein, even though the
painting is titled Melancholia, *one can enjoy the exquisite*
execution of the figure's dress without delving too far into the
inherent complexity of his situation.

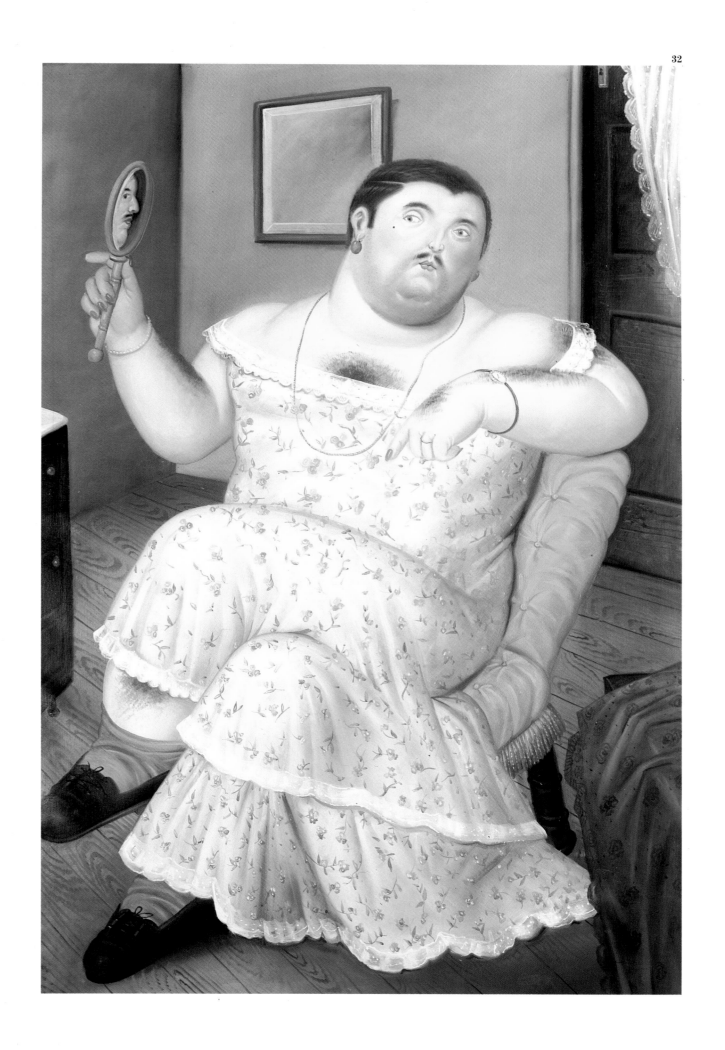

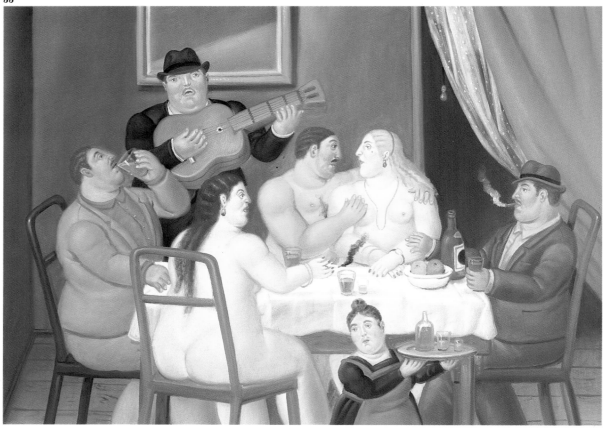

33

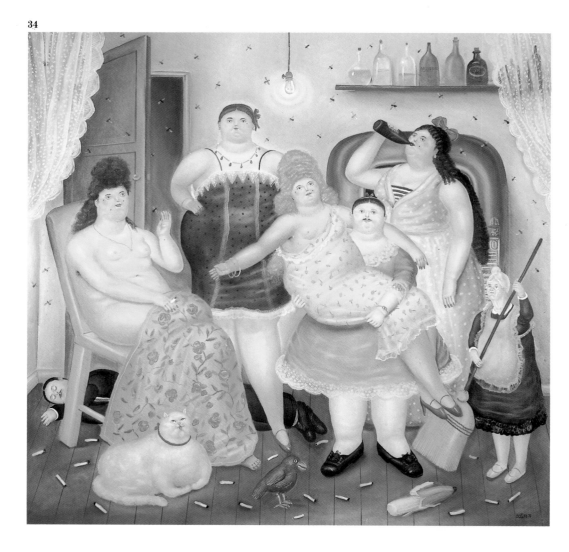

34

33, 34, 35 The Dinner, *1994;* The House of María Duque, *1970;* The House of Amanda Ramirez, *1988. Botero depicts brothels as scenes of popular culture, as family businesses devoid of any sordid connotations. His houses of prostitution are establishments that initiate youths into the mysteries of sex, and that honorable citizens frequent to appease the impelling demands of nature, subordinated as these demands may be to the strictness of the marital institution in Colombia. Thus, it is not astonishing that even a perceptive commentator such as Alberto Moravia, possibly misled by an inaccurate translation of the work's title, could be unaware that the setting is a whorehouse and speak of a father "holding a little girl on his knees," and speculate on the health of that "family."*

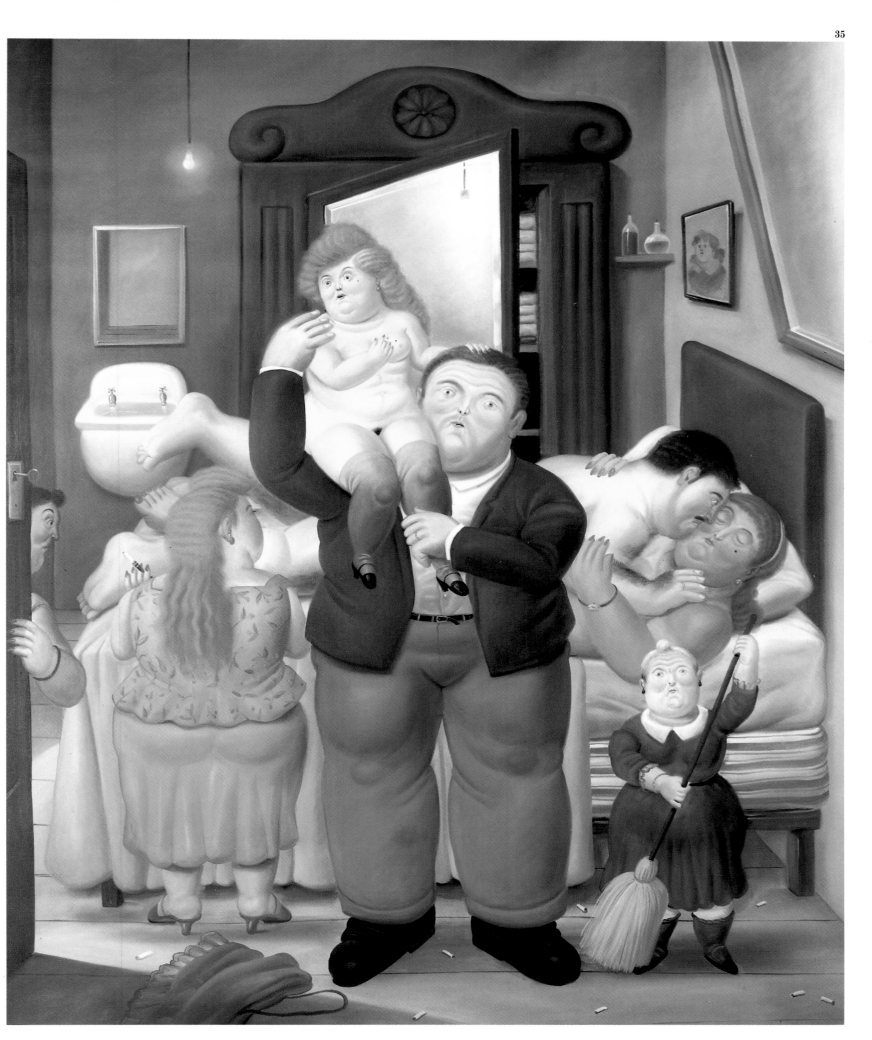

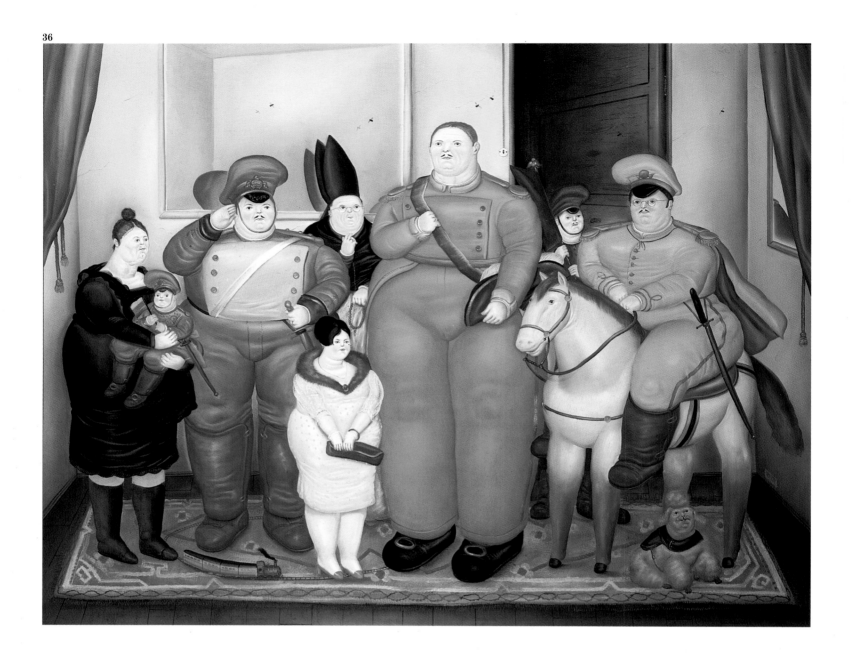

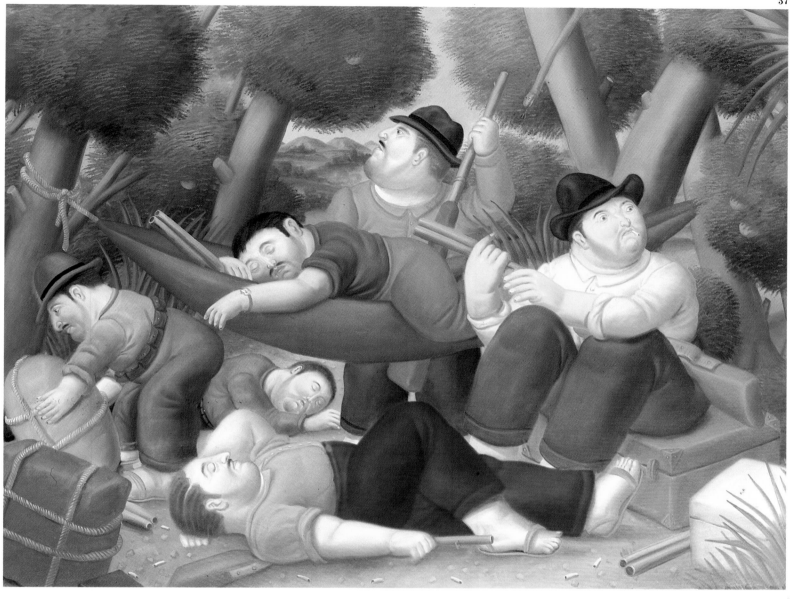

36, 37 Official Portrait of the Military Junta, *1971*; Guerrillas, *1988*.
*"I cannot deny that some of my works arose out of a satirical idea.
When I painted the* Military Junta, *there were juntas
everywhere . . . a sort of invitation to produce just such a
painting."* In the same breath, however, Botero avowed that his
works never display any genuine hatred *"since that would be
incongruous with painting."* This belief led him to represent the
sinister members of a military junta as a group of children
momentarily halting their games to pose, and a band of fierce
guerrillas as easygoing peasants comfortably resting after their
toil.

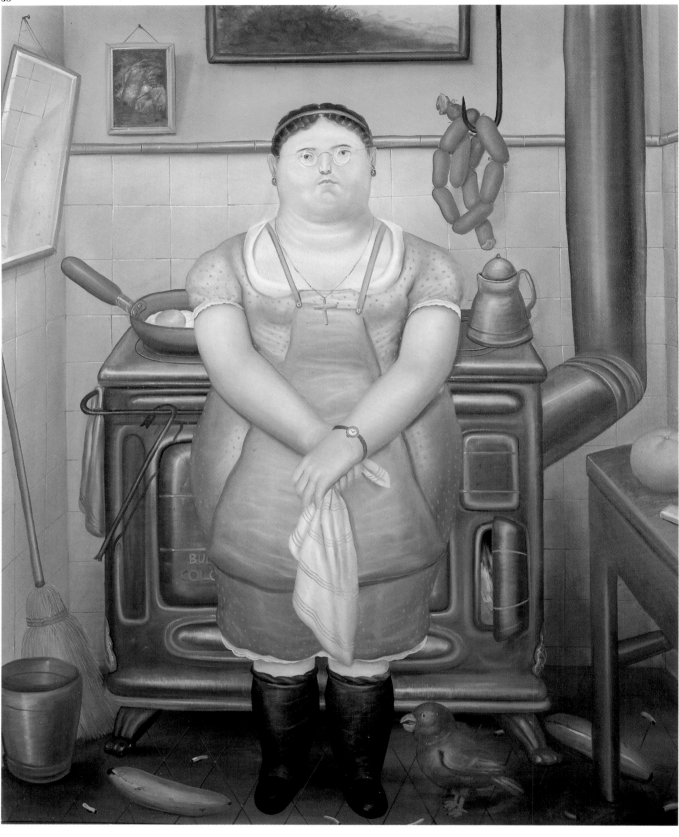

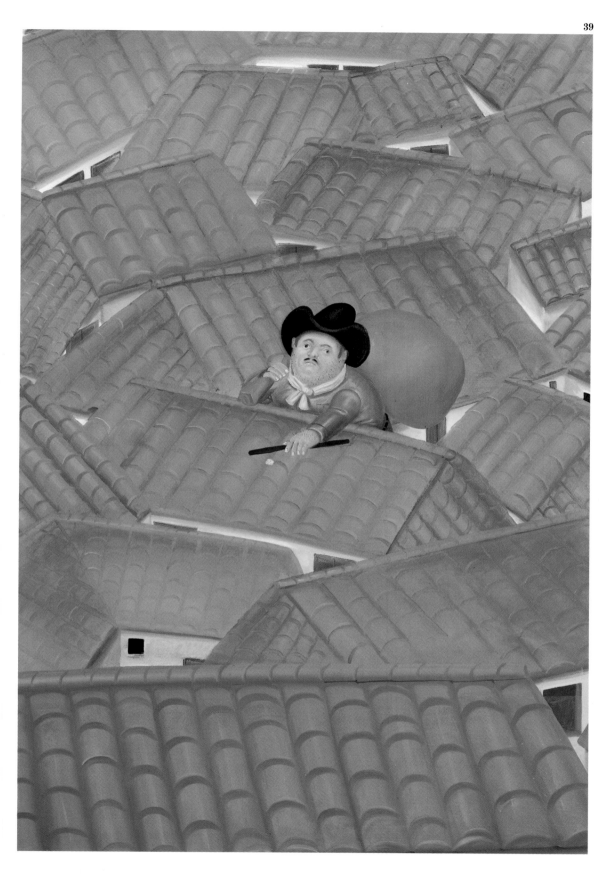

38, 39 The Maid, *1974; The Burglar, 1980. The stillness and seeming defenselessness of Botero's characters elicit an empathic sense of tenderness. Such is the case with this maid and her somewhat mannish air, drab clothes, and humble workplace. The harmless burglar, lost in a maze of roofs with his meager loot slung over his shoulder, looks as if he just escaped from the pages of a children's storybook.*

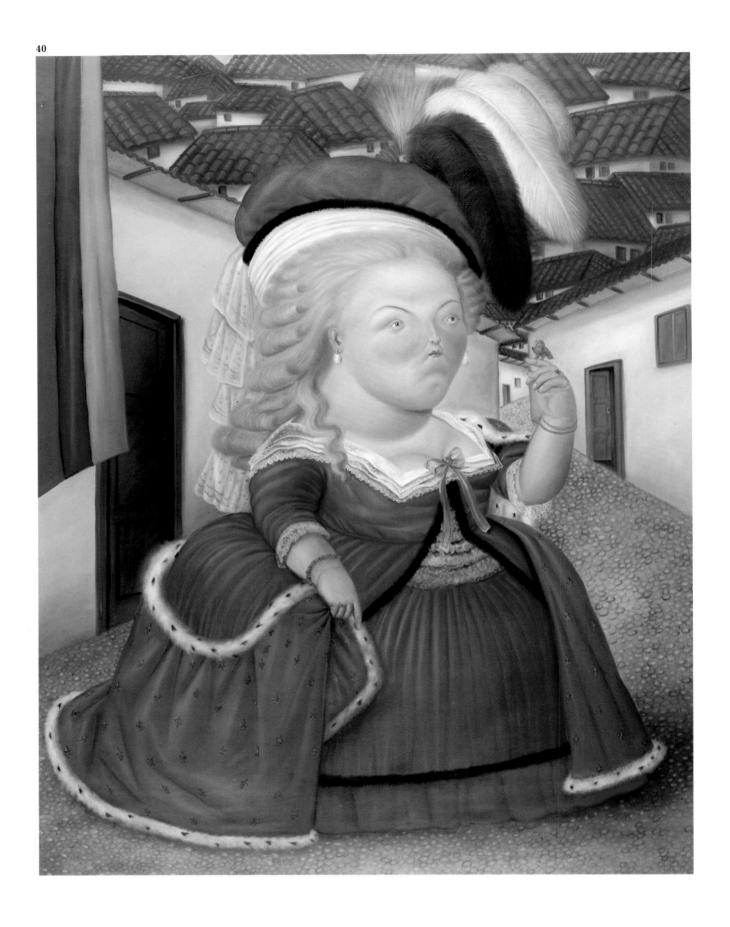

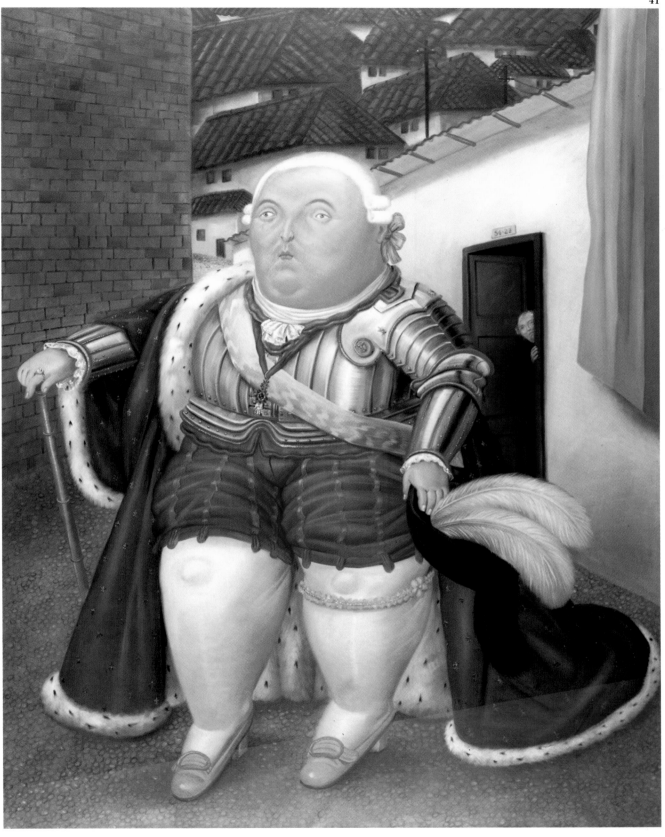

40, 41 Louis XVI and Marie Antoinette on a Visit to Medellín, Colombia, *1990. Diptych. Here, France's last royal couple pays an unlikely visit to the labyrinthine alleys of Medellín. The lavishness of their attire attests to Botero's extraordinary technical deftness, and contrasts dramatically with the colonial surroundings of whitewashed walls and grayish brown roofs.*

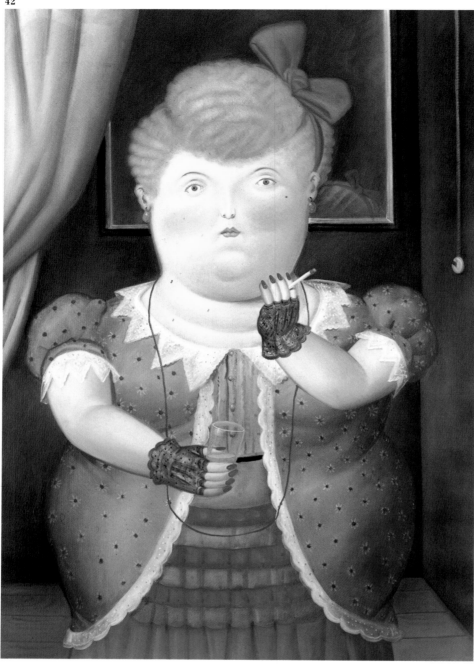

Human Figures and Characters

It is difficult to divide Botero's work neatly into figurative paintings and still lifes. His choice of motifs—from children and bananas, to vases and military personnel—is always based on their formal characteristics. Human figures in his pictures are reduced to mere corporeity. They rarely let any sign of intellectual activity transpire, seemingly affected by some sort of ontological stupidity. Botero, who likes to quote Cézanne's request that one of his models would pose "as if she were an apple," views the human mind as something inherently incongruent with painting. As a result, he declares that he needs "forms, not people." Their eyes, the anatomical feature most revealing of the sitter's soul, are frequently squinty and gaze with bewilderment at some vague point, rarely directed toward the viewer. The artist's intention is to not distract the viewer's attention from the essential tactile values of his paintings.

42 Woman with a Red Bow, *1990.*
It is the sensuousness of their forms that makes Botero's figures so engaging, as they conceal no mystery beyond their unlikely deformation. A femme fatale may easily don the aspect of this dowdily dressed, ruddy woman, with her lace gloves, minuscule cigarette, immense bow, and unfathomable countenance.

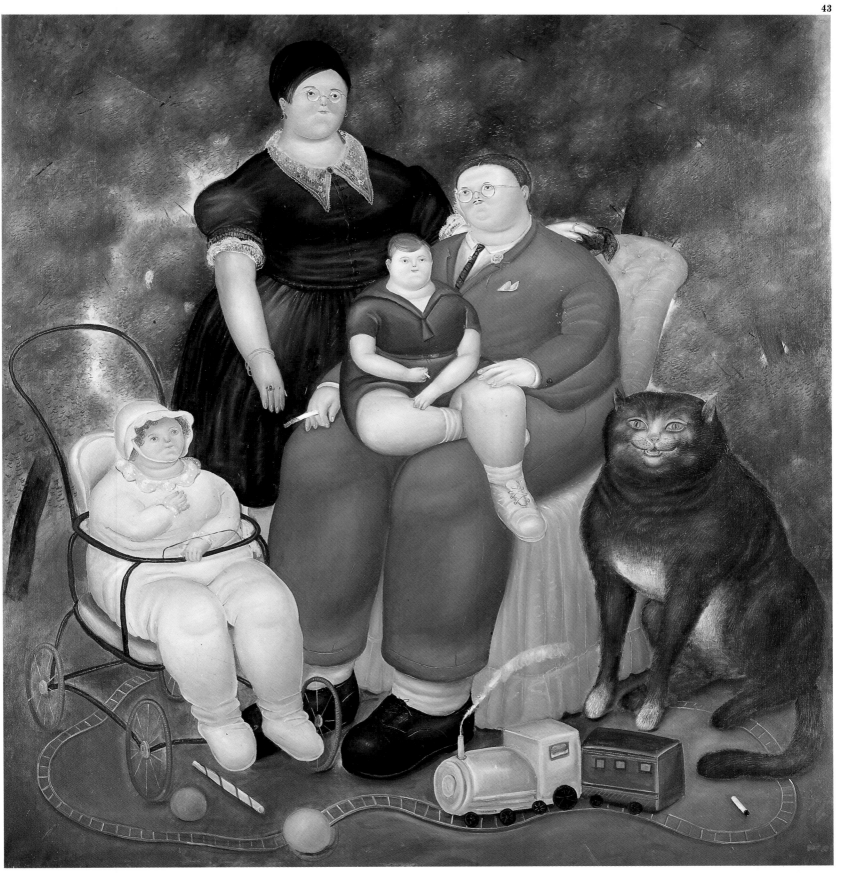

43 Family Scene, *1969. Different clothes and sizes reveal the ultimate identities of the characters in this painting. However, their distinctive air of peacefulness homogenizes their features. The adults have childlike faces, and the children, especially the young boy smoking a cigarette while sitting on his father's lap, appear surprisingly mature. The loss of individual traits is the exchange for their state of seemingly indefinite contentment.*

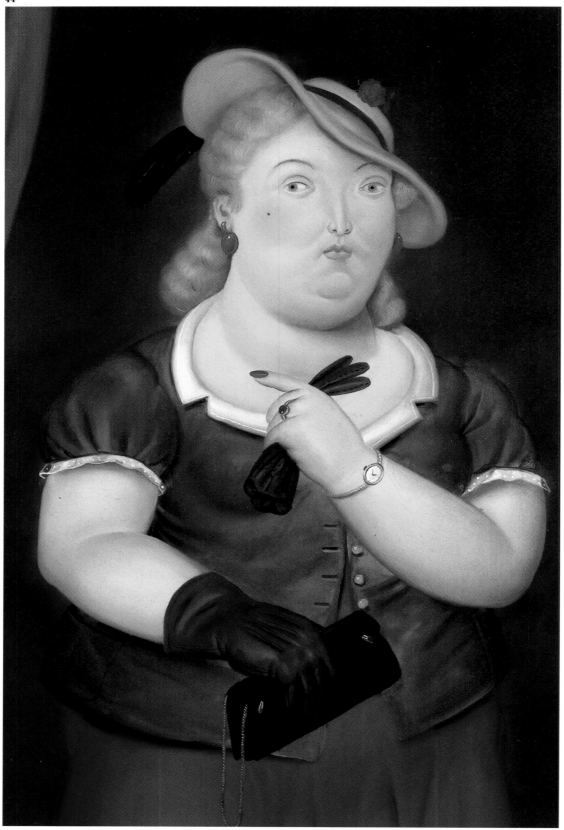

44 Woman in a Hat, *1986. Set against a neutral background typical of Baroque portraits, this painting illustrates that in Botero's works light is not incidental. Instead, as in the polished figures painted by Botero's beloved Piero della Francesca, it radiates from within and permeates their entire surroundings.*

45 Saint Michael, Archangel, *1986. The artist once recalled, "As a child in Colombia, I used to go to church; ours is a very religious country. . . . At home we had several reproductions of the Virgin, the Sacred Heart, and the saints. For me, they all spelled beauty. The Madonnas were invariably perfect and, in the church, those wooden polychrome statues were all glossy and gentle."*

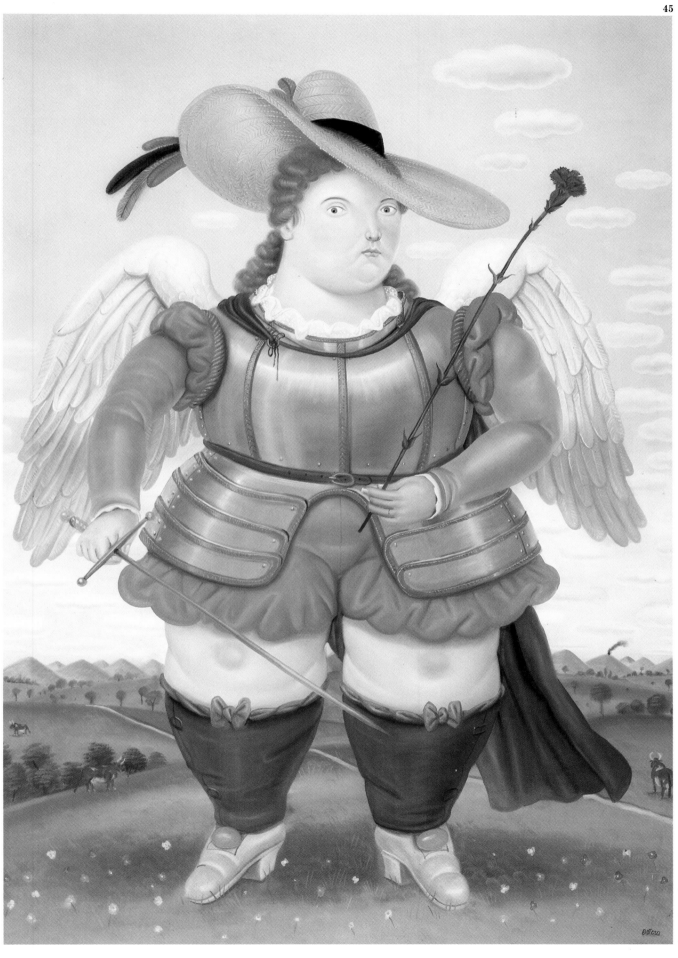

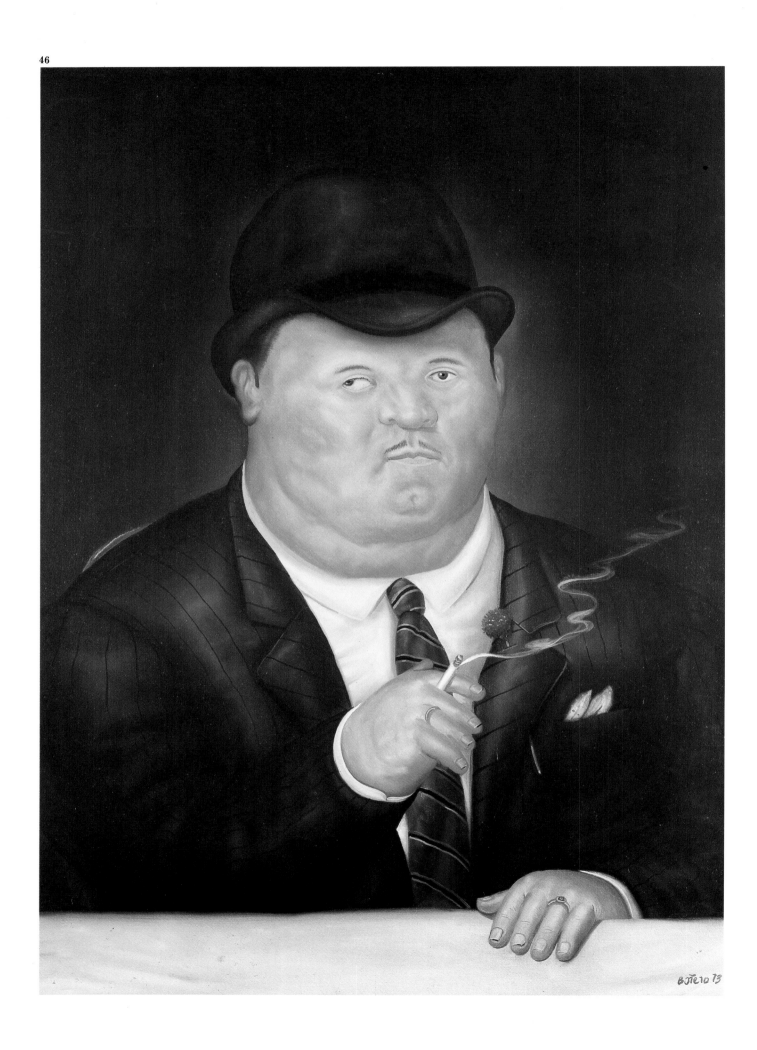

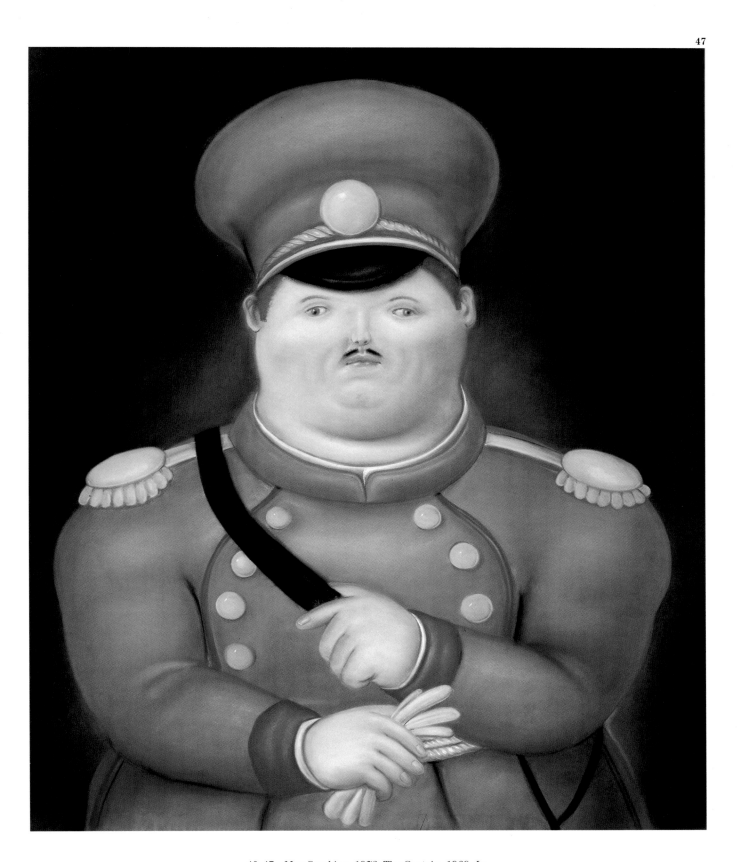

46, 47 Man Smoking, *1973;* The Captain, *1969. In spite of their imposing presences, the characters in Botero's paintings always appear harmless. The clumsy sluggishness suggested by their spherical bodies, diminutive hands, and pronounced squint, regardless of their roles, plunges them into a sort of childlike melancholy.*

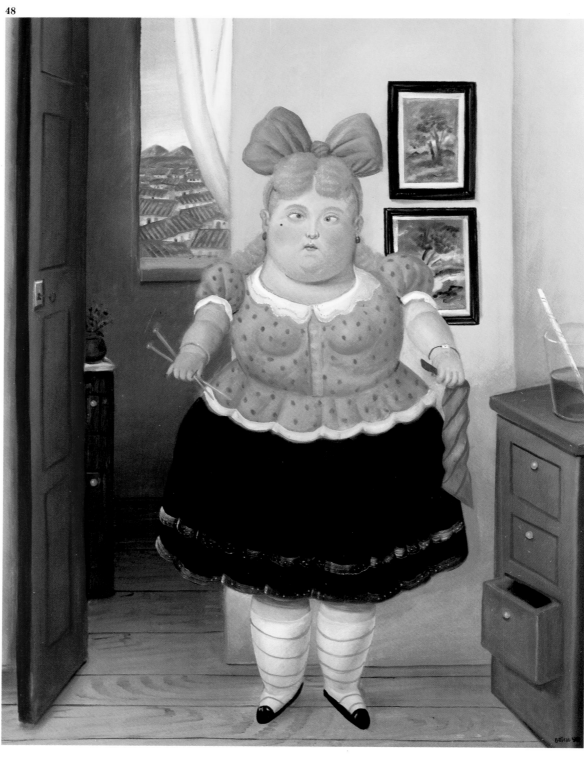

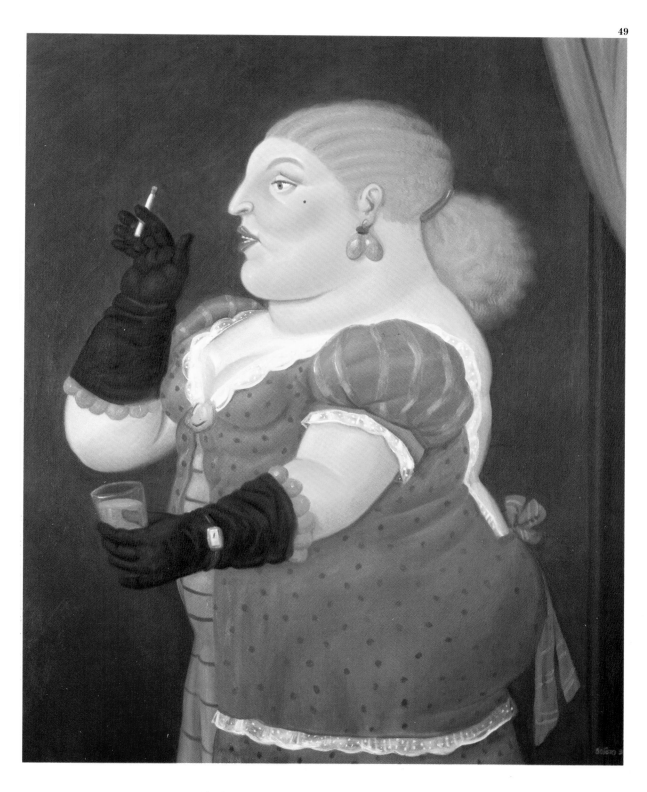

48, 49 The Seamstress, *1990; Woman in Profile,*
1992. As observed by the Peruvian writer Vargas
Llosa, the happiness radiating from Botero's
paintings stems from "the luminous, sensuous, and
contented form with which their ample curves have
been delineated, the miniaturist's daintiness with
which the brush has pursed their tiny mouths . . .
and the generosity with which it has strewn and
blended the colors to the point that the modest
dwellings . . . look like palaces, while their ludicrous
and old-fashioned outfits dazzle us as if they were
royal fineries."

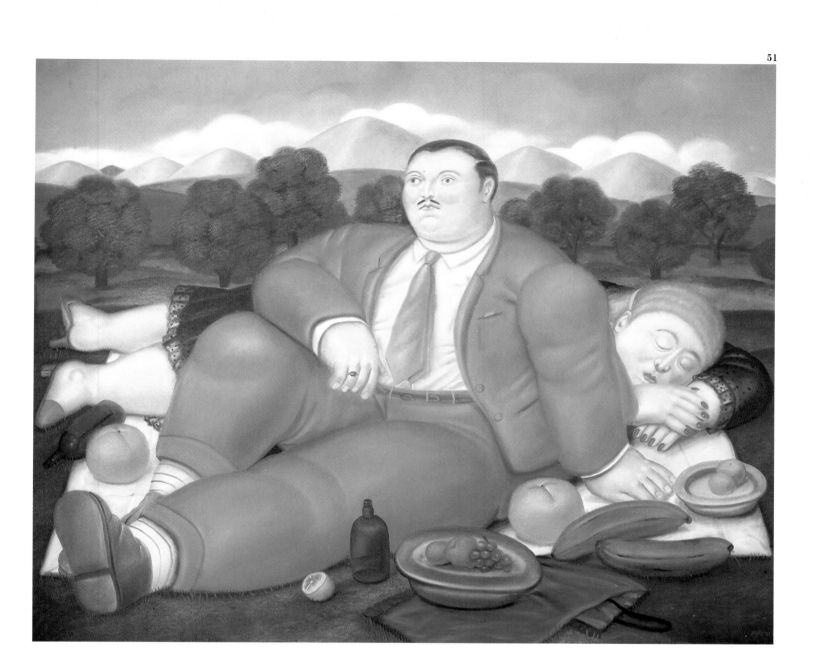

50, 51 A Man and a Woman, *1989;* The Siesta, *1982.*
Memory plays a crucial role in Botero's paintings.
Vargas Llosa commented on the archaic flavor of
works such as these two: "You don't need to have
actually visited the Colombian towns of Antioquia in
the 1940s to be able to identify the social reality
against which Botero's imagery is set. Just as I can't
help reliving in it the Peru of my childhood . . . any
Latin American will recognize in this carousel of
images certain manners of feeling, dreaming, and
acting that are typical of the cities and towns of the
interior of any country on our continent."

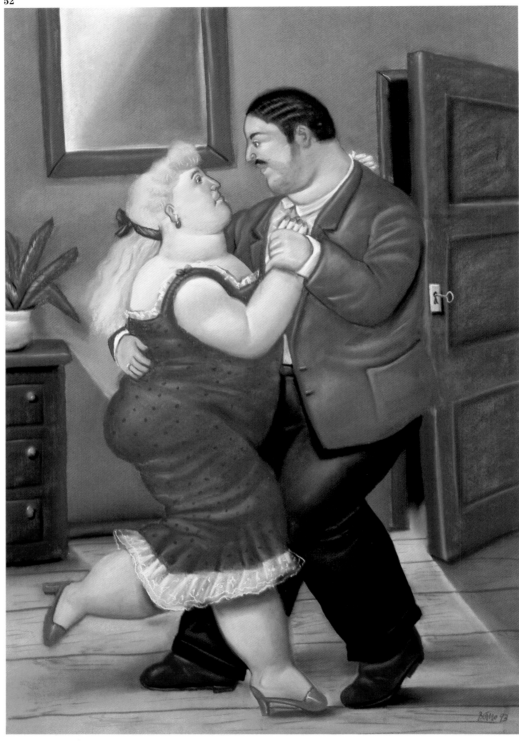

52 Dancing, *1993. Despite their rotund frames, Botero's figures exhibit a considerable lightness when in motion. As in a work with the same title painted six years earlier (see plate 29), here the woman's raised leg further accentuates the couple's weightless quality.*

53 Mother and Son, *1993. Old age does not exist in Botero's peculiar universe. The freshness of its citizens, ensconced in their indefinite youth, might make one mistake this scene for one of a little girl cradling her doll.*

List of Plates

1 The Botero Exhibition, *1975. Oil and collage on canvas, 20½ × 77⅛″ (52 × 196 cm)*

2 Self-Portrait the Day of My First Communion, *1970. Oil on canvas, 42⅞ × 37″ (109 × 94 cm)*

3 Delfina, *1972. Oil on canvas, 49⅝ × 37⅜″ (126 × 95 cm)*

4 Self-Portrait with Louis XIV (after Rigaud), *1973. Oil on canvas, 114 × 77⅝″ (289.5 × 197 cm). Museo de Arte Contemporáneo, Caracas*

5 Self-Portrait with Sofía, *1986. Oil on canvas, 76¾ × 37″ (195 × 94 cm)*

6 Self-Portrait, *1994. Oil on canvas, 52 × 39″ (132 × 99 cm)*

7 Mona Lisa, Age Twelve, *1959. Oil and tempera on canvas, 83⅛ × 77″ (211 × 195.5 cm). The Museum of Modern Art, New York*

8 Mona Lisa, *1978. Oil on canvas, 73⅝ × 65⅜″ (187 × 166 cm)*

9 Menina (after Velázquez), *1978. Oil on canvas, 78¾ × 72″ (200 × 183 cm)*

10 Rubens and His Wife, *1965. Oil on canvas, 78 × 73¼″ (198 × 186 cm)*

11 Le Déjeuner sur l'Herbe, *1969. Oil on canvas, 70⅞ × 75″ (180 × 190.5 cm)*

12 The Card Player, *1988. Oil on canvas, 51⅛ × 74″ (130 × 188 cm)*

13 Venus, *1989. Oil on canvas, 79⅛ × 51⅝″ (201 × 131 cm)*

14 The Bath, *1989. Oil on canvas, 98 × 80¾″ (249 × 205 cm)*

15 Nude, *1988. Oil on canvas, 39⅜ × 29⅛″ (100 × 74 cm)*

16 The Letter, *1976. Oil on canvas, 58⅝ × 76⅛″ (149 × 194 cm)*

17 Guitar and Chair, *1983. Oil on canvas, 63 × 46½″ (160 × 118 cm)*

18 Pear, *1976. Oil on canvas, 94⅞ × 77⅛″ (241 × 196 cm)*

19 Still Life with Cabbage, *1967. Oil on canvas, 53⅞ × 67¾″ (137 × 172 cm)*

20 Oranges, *1989. Oil on canvas, 66⅞ × 77⅝″ (170 × 197 cm)*

21 Happy Birthday, *1971. Oil on canvas, 61 × 74¾″ (155 × 190 cm)*

22 Still Life with Watermelon, *1976. Oil on canvas, 66⅞ × 76¾″ (170 × 195 cm)*

23 Fruit Basket, *1972. Pastel on paper, 48 × 55⅛″ (122 × 140 cm)*

24 Flowerpot, *1974. Oil on canvas, 89¾ × 75¼″ (228 × 191 cm)*

25 The Bootblack, *1989. Oil on canvas, 78 × 51⅝″ (198 × 131 cm)*

26 A Stroll by the Lakeside, *1989. Oil on canvas, 81⅞ × 56¾″ (208 × 144 cm)*

27 Cat on a Roof, *1978. Oil on canvas, 34¼ × 30¼″ (87 × 77 cm)*

28 The Street, *1987. Oil on canvas, 57⅛ × 56¾″ (145 × 144 cm)*

29 Dancing, *1987. Oil on canvas, 76¾ × 51⅛″ (195 × 130 cm) Fondation Gianadda, Martigny*

30 The Musicians, *1979. Oil on canvas, 85⅜ × 74¼″ (217 × 90 cm)*

31 Woman Falling from a Balcony, *1994. Pastel, 40⅛ × 28″ (102 × 71 cm)*

32 Melancholia, *1989. Oil on canvas, 76 × 51⅛" (193 × 130 cm)*

33 The Dinner, *1994. Oil on canvas, 33⅛ × 45¼" (84 × 115 cm)*

34 The House of María Duque, *1970. Oil on canvas, 70⅞ × 73¼" (180 × 186 cm)*

35 The House of Amanda Ramirez, *1988. Oil on canvas, 88⅝ × 73⅝" (225 × 187 cm)*

36 Official Portrait of the Military Junta, *1971. Oil on canvas, 68½ × 86¼" (174 × 219 cm)*

37 Guerrillas, *1988. Oil on canvas, 60⅝ × 79⅛" (154 × 201 cm)*

38 The Maid, *1974. Oil on canvas, 76⅜ × 60⅝" (194 × 154 cm)*

39 The Burglar, *1980. Oil on canvas, 65 × 43¾" (165 × 111 cm)*

40, 41 Louis XVI and Marie Antoinette on a Visit to Medellín, Colombia, *1990. Diptych, each panel 107⅛ × 81⅞" (272 × 208 cm)*

42 Woman with a Red Bow, *1990. Oil on canvas, 66⅞ × 46⅞" (170 × 119 cm)*

43 Family Scene, *1969. Oil on canvas, 83⅛ × 76¾" (211 × 195 cm)*

44 Woman in a Hat, *1986. Oil on canvas, 44½ × 29⅛" (113 × 74 cm)*

45 Saint Michael, Archangel, *1986. Oil on canvas, 76¾ × 53½" (195 × 136 cm)*

46 Man Smoking, *1973. Oil on canvas, 53⅛ × 37" (135 × 94 cm)*

47 The Captain, *1969. Pastel, 53½ × 44½" (136 × 113 cm)*

48 The Seamstress, *1990. Oil on canvas, 48⅞ × 37⅜" (124 × 95 cm)*

49 Woman in Profile, *1992. Oil on canvas, 50¾ × 40⅛" (129 × 102 cm)*

50 A Man and a Woman, *1989. Oil on canvas, 42½ × 33⅛" (108 × 84 cm)*

51 The Siesta, *1982. Oil on canvas, 53⅛ × 67¾" (135 × 172 cm)*

52 Dancing, *1993. Pastel on paper, 37 × 26" (94 × 66 cm)*

53 Mother and Son, *1993. Pastel on paper, 37 × 24⅜" (94 × 62 cm)*

Selected Bibliography

Bonald, J. M. Caballero. Botero, la Corrida. *Madrid: Lerner & Lerner Editores, 1989.*

Lascault, Gilbert. Botero elogio de las esferas, de la carne, de la pintura y de los otros muchos casos. *Madrid: Lerner & Lerner Editores, 1992.*

Spies, Werner. Botero: Paintings and Drawings. *Munich: Prestel, 1992.*

Spies, Werner, ed. Fernando Botero. Pinturas, dibujos, esculturas. *Exh. cat. Madrid: Centro de Arte Reina Sofía, 1987.*

Sullivan, Edward J. Botero, dessins et aquarelles. *Paris: Cercle d'Art, 1992.*

Series Coordinator, English-language edition: Ellen Rosefsky Cohen
Editor, English-language edition: Margaret E. Braver
Designer, English-language edition: Judith Michael

Library of Congress Catalog Card Number: 96–86848
ISBN 0–8109–4681–5

Printed and bound in Spain by La Polígrafa, S.L.
Parets del Vallès (Barcelona)
Dep. Leg.: 35.282 - 1996